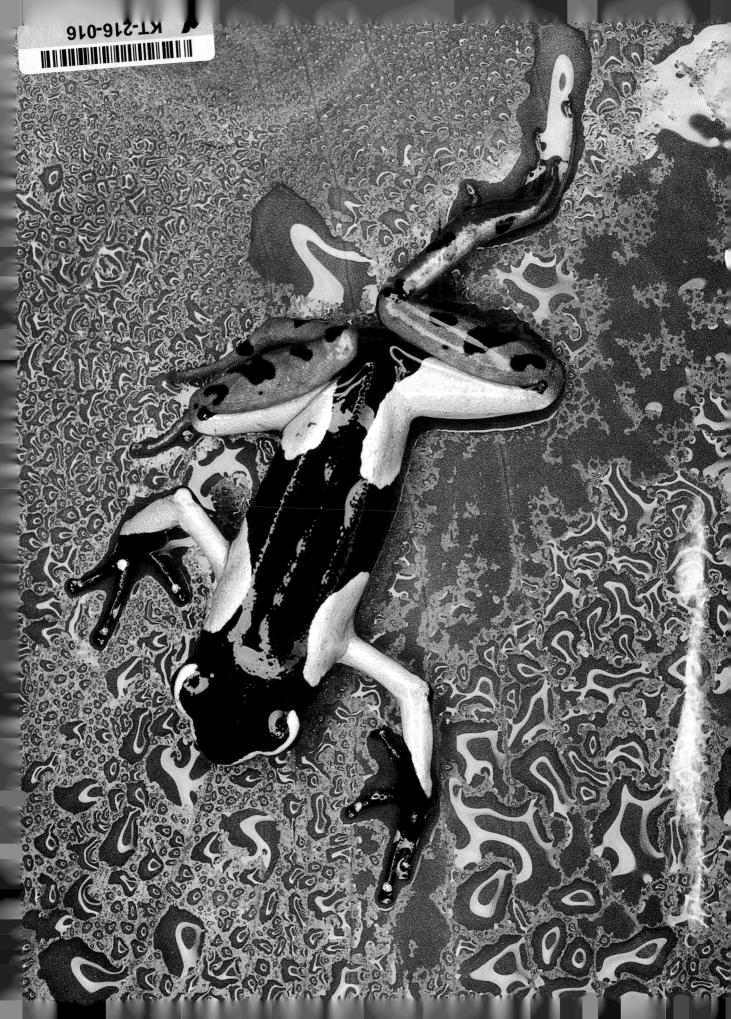

MOZAMBIQUE

Mozambique
Channel

Contents

Map symbols

—— Main roads

- - - Secondary routes (4x4)

National parks and reserves

Key to photo symbols

Wide angle lens: from 20 to 35mm

Medium focus lens: from 70 to 200mm

Long focus or telephoto lens: from 300 to 600mm

Macro lens: 60mm or 105mm

Moror

Morombe

Toliara
(Tuléar)

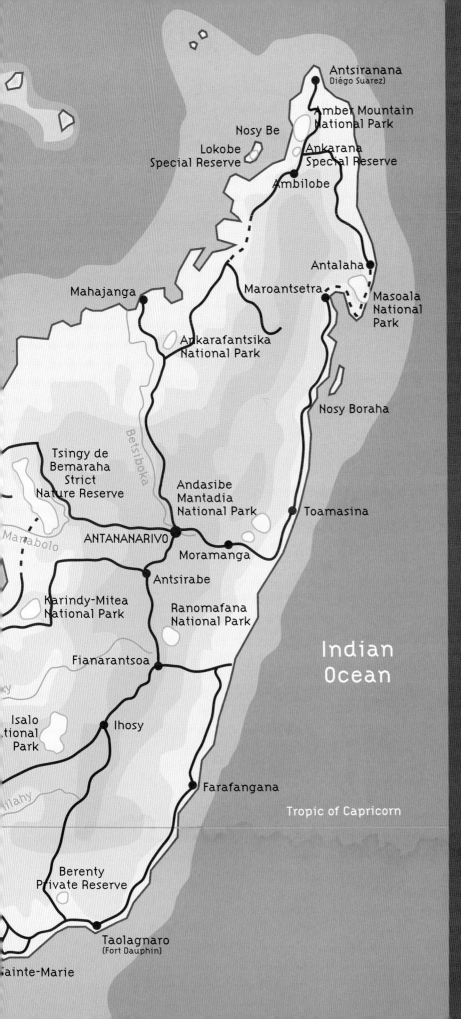

Antsiranana
(Diégo Suarez)

Amber Mountain
National Park

Nosy Be

Lokobe
Special Reserve

Ankarana
Special Reserve

Ambilobe

Antalaha

Maroantsetra

Masoala
National
Park

Mahajanga

Ankarafantsika
National Park

Nosy Boraha

Betsiboka

Tsingy de
Bemaraha
Strict
Nature Reserve

Andasibe
Mantadia
National Park

Mania bolo

ANTANANARIVO

Toamasina

Moramanga

Antsirabe

Karindy-Mitea
National Park

Ranomafana
National Park

Fianarantsoa

Indian
Ocean

Isalo
National
Park

Ihosy

Farafangana

Tropic of Capricorn

Berenty
Private Reserve

Taolagnaro
(Fort Dauphin)

Sainte-Marie

The immeasurable wealth of Madagascar's bio-diversity would require thousands of pages to do it justice, so this book is simply an introduction to the world's fourth biggest island. It has so many unique qualities that this volume is an invitation to discover a whole world in itself. Here is a location that represents one of the most precious examples of natural heritage on the planet, even though human impact is threatening its incomparable habitats. The 'Red Island' as it is also known, is nevertheless a land of adventure and surprises, where wild space offers unforgettable experiences. Deforestation has certainly inflicted some irreparable damage on the natural world, but entire regions still offer opportunities to identify and explore new species — as shown by recent discoveries of both plants and animals new to science. Truly a live museum, Madagascar is a paradise on reprieve.

MADAGASCAR

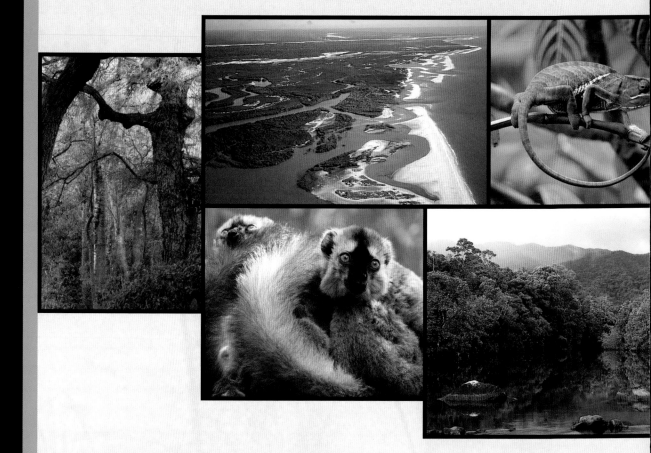

Eons ago, Madagascar was part of the single super-continent known as Gondwanaland, comprising the various continents we know today. Around 165 million years ago, it split from Africa and drifted some 400 kilometres off the east coast, level with what is now Mozambique, separated by the Mozambique Channel. To the north-west, north and east of the main island lie the island groups of the Comoros, the Mascarenes and the Seychelles, with the latter sharing its continental origins with Madagascar. The first humans are said to have arrived on Madagascar around 2,000 years ago, but we do not know if it was the Asians who came first, followed by the Africans, or if the Afro-Asian mixing took place prior to settlement. Just under 1,000 years later, Arab traders came to settle here. This racial mix is visible in the Madagascan faces, divided between 20 or so ethnic groups, yet united by the common Malagasy language. Coveted by several European countries since the sixteenth century, Madagascar became a French colony in the late nineteenth century; since 1960 it has been an independent state and now has around 18 million inhabitants. Madagascar covers an area of some 587,000 square kilometres, stretching for 1,580 kilometres north-south and 600 kilometres east-west. Its relief is dominated by highlands that occupy over half the territory, broken by a north-south range of mountains close to the eastern shore, reaching their highest point at Mount Maromokotro (2,876 metres). The island is largely covered with highly weathered lateritic soils, which give rise to the alternative name of Red Island. These soils overlie sandstone and karstic sedimentary beds. Madagascar has several distinct vegetation zones: to the east, inland from the narrow coastal plains along the Indian Ocean, are opulent wet forests nourished by the frequent, abundant rainfall – up to 4,000 millimetres a year in some places. On the Masoala peninsula, the rainforest runs right down to the shore, lapped by the ocean waves. The dry territories in the south, where the annual rainfall is no more than 500 millimetres, are the realm of xerophytic (drought tolerant) vegetation, while gallery forests border the large rivers. The west coast consists of savannahs and dry deciduous forests. Around the 5,000-kilometre coastline, Madagascar has one of the

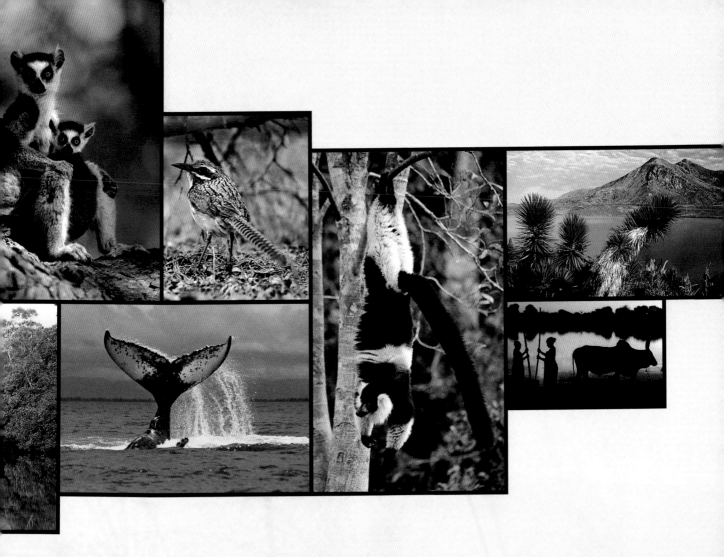

largest mangrove areas in the world, covering some 330,000 hectares and concentrated in the west. With their roots deeply anchored in muddy shores, the mangrove trees provide effective protection against coastal erosion. Madagascar also has beaches of white sand fringing the crystal-clear sea where coral reefs are home to a plethora of marine life. In the shallow coastal waters humpbacked whales come every year to calve.

Madagascar's fauna and flora have evolved partly because it is an isolated island, but also because it originated as a continental fragment. The figures speak for themselves: the island is colonised by around 12,000 plant species, of which 70 – 80 percent are endemic. Seven out of the world's eight species of baobab trees are found in Madagascar – and six of these are endemic. Over 1,000 species of orchid, 85 percent of which are endemic, thrive on the Malagasy soil. The entire Didiereaceae family is unique to Madagascar. The flora of the spiny forest, typical in the south of the island, is 95 percent endemic. In the animal kingdom, the figures are equally staggering: of the 117 species of wild

mammals noted, 90 percent are endemic. There are 34 endemic species of lemur – with 25 sub-species. Of some 300 species of reptiles, including 60 harmless snakes, 90 percent are endemic. More than half of the world's chameleons have their home here, and 99 percent of the 183 species of frogs are endemic, with more being discovered each year. Amongst the 258 bird species are some of the rarest in the world and 115 are endemic. Madagascar is home to 3,000 species of moths and butterflies. In this book, we invite you to join us on a pictorial journey to discover some of this outstanding wildlife. Firstly, we look at the rainforests of Andasibe-Mantadia and Ranomafana and then move to the rocky labyrinths of the Isalo, before stopping off in Berenty to meet the ring-tailed lemurs. Following an obligatory visit to the avenue of baobabs, our journey will take us to the rocky limestone peaks known as the 'tsingys' of Bemaraha and Ankarana, via the forests of Ankarafantsika and Lokobe. We will end by entering the wild paradise of Amber Mountain and the unfathomable Masoala peninsula.

Andasibe-Mantadia

About 130 kilometres east of Tananarive, Toamasina province in the central Madagascan highlands is home to one of the island's most fabulous protected areas, and incidentally, most accessible and so relatively often visited. Since the 1990's, the Andasibe-Mantadia National Park has united two protected areas: the Andasibe Special Reserve, or Périnet to give it its colonial name, but locally still called Analamazaotra; and Mantadia National Park. These two territories barely 20 kilometres apart cover areas of mountain rainforest, rising in tiers with an average altitude of 1,000 metres. This typical vegetation consists of primary forest, and degraded forest caused by the previously uncontrolled exploitation of timber.

The Andasibe National Park is the closest protected site to Antananarivo, the capital of Madagascar, and so is relatively easy to reach. The 810-hectare park can be explored using the many discovery trails. The undisputed star of Andasibe is the indri and this large black and white coated lemur stands out clearly in the green forest. The largest of all the prosimians, larger specimens may grow to over one metre and weigh six to seven kilograms. At dawn and at the end of the day it gives a plaintive territorial call which morning visitors on the trails cannot fail to hear and home in on. After leaving the haunting indris' concert, you can head eastwards on paths that are not too steep to

The indri is confined to a strip in north-east Madagascar, where it lives in small family groups, each dominated by the females who always have first choice of food. This largest of the lemurs often stations itself in the tops of the trees, hidden amongst the dense vegetation. To photograph it, you have to wait until it comes down to feed on the lower branches, when it is possible to take a portrait using a medium long lens. It moves from tree to tree in spectacular leaps that can be up to ten metres.

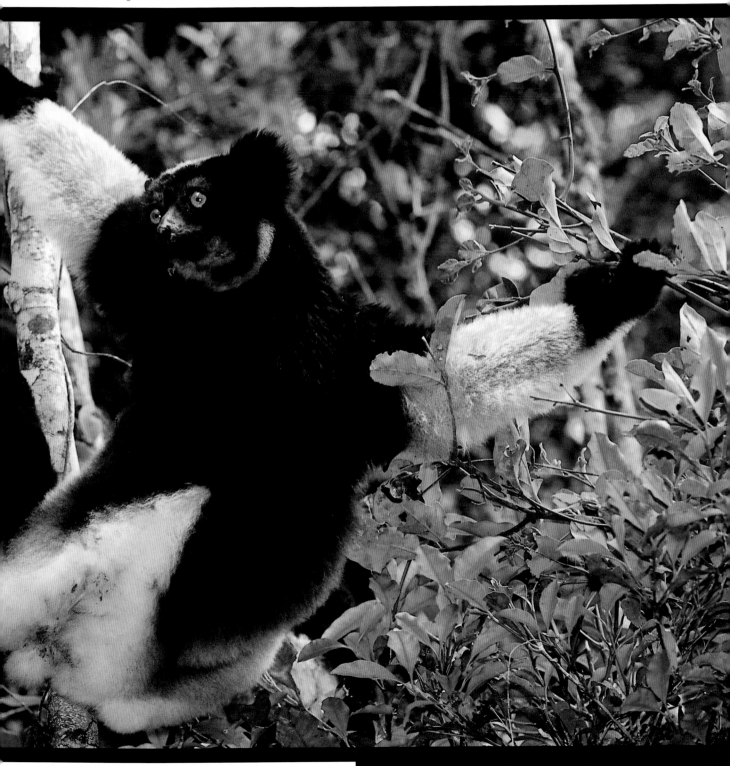

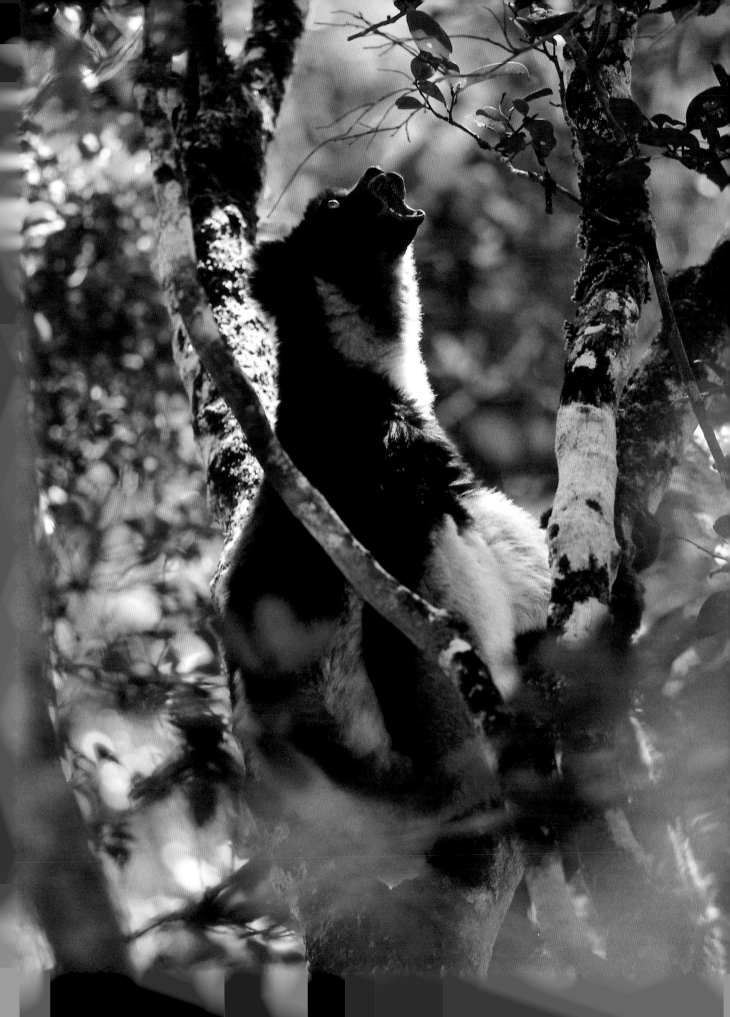

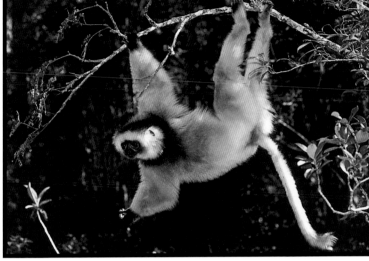

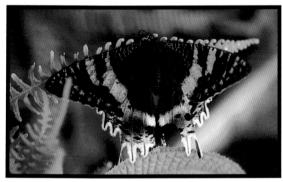

Every morning at daybreak, the indris wake the forest with their plaintive cries, loud enough to carry for some three kilometres. A slow approach, crawling on the stomach, was used to take this shot with a wide angle. The brown lemur (above) uses its calls to prevent groups running into one another. The greedy diademed sifaka (top right) sometimes drives it to leave the canopy to look for fallen fruit in the leaf litter. A medium long lens is enough to capture its acrobatics, but the half-light of the undergrowth may make flash necessary. The same lens was used for taking this sunset moth, a magnificent specimen of one of the 3,000 species of moths and butterflies noted in Madagascar.

the boomerang-shaped Green Lake. Not far from the lake, clumps of bamboo with slender, rustling leaves provide food for the grey bamboo lemur, which feeds almost exclusively on this grass and is also to be found near the orchid garden. On the edge of the park, the garden offers a fine overview of many elegant, delicately-coloured flowers. A short walk southwards brings you to the placid, waterlily-covered Red Lake. The Andasibe National Park also has intact and much less visited forest territories, particularly in the east. These are difficult to get to, but they offer the prospect of leaving the beaten track to explore the evergreen forest and its inhabitants. The red-bellied lemur, which lives in family groups, just might show its face for the occasion. Limited to the primary and secondary rainforests in the east of the country, the small population means that you will need to be both patient and discreet to spot it. Thirty or so species of amphibians live in the Andasibe National Park, amongst them the golden mantella, whose brightly coloured orange skin warns that it is poisonous. Numerous birds also colonise this forest cathedral, like the nuthatch vanga with its delicate bluish glints; the red-tailed vanga, of which only the male has a red tail; the short-legged groundroller with its

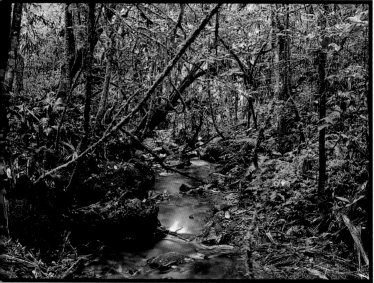

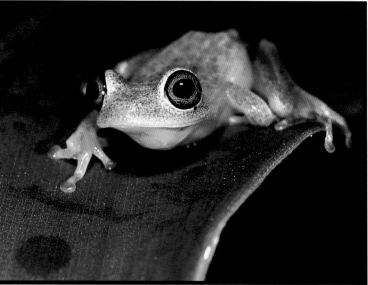

A wide angle is recommended for taking Mantadia's damp undergrowth on a day of deluging rain, which conveys the rainforest atmosphere. More active at night, the tree frog, Mantidactylus liber, grows no bigger than four centimetres, so it was taken using a 105mm macro lens and lit with flash. The same lens made it possible to capture the flamboyant Impatiens flowers. The Parson's chameleon is very widespread in tropical forests and its slow movements permit you to use a long exposure instead of flash. But a tripod is then essential, because of the low light level filtering through the forest canopy. Approached cautiously, this superb reptile was photographed with the aid of a macro lens.

iridescent livery of green and mauve; and the brown mesite all dressed in brown – to name but a few of the 109 species known here.

Maybe you will surprise an eastern woolly lemur sleeping in the fork of a tree, waiting for darkness to fall before it becomes active again. As lemurs are for the most part nocturnal, night walks can provide the opportunity to see them. But the greater dwarf lemur is only active in summer, and hibernates during the cold season. Look out also for the brown mouse lemur, a little furry animal with big, dark eyes. This falls prey to predators, including mammals, reptiles and birds – sometimes being snatched from inside trees used as a daytime refuge. The reptiles are well represented, with some 39 species including 11 chameleons that are Andasibe's pride and joy. The Parson's chameleon shares this habitat with, amongst others, its smaller cousins such as the short-horned chameleon, and the big-nosed chameleon. Besides the 11 species of hedgehog-like tenrecs, the Andasibe wetlands are also the domain of the red forest rat, which digs its multi-chambered burrows with multiple entrances beneath fallen branches on the ground. This rodent,

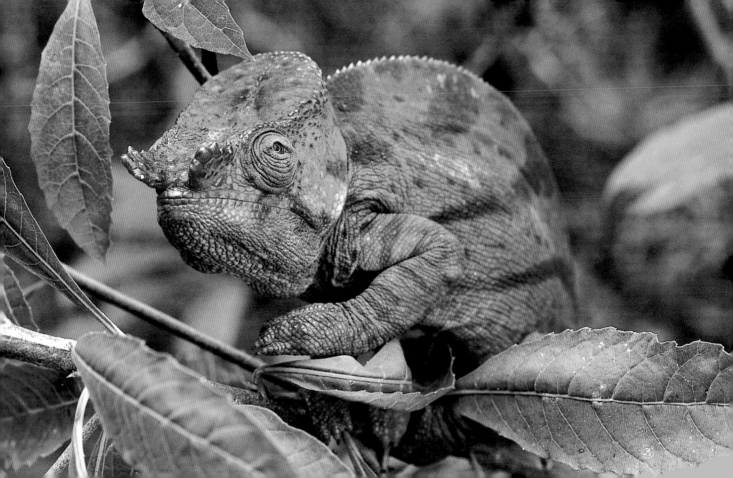

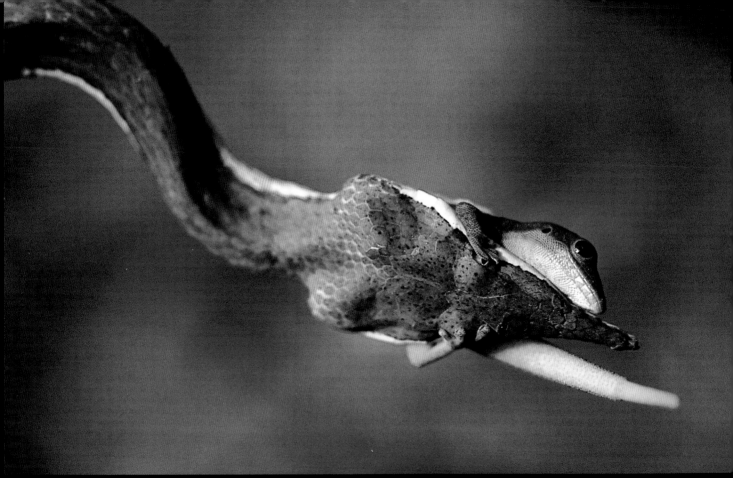

which eats seeds and fruit, can be found in the Mantadia National Park, further north.

Less accessible, and hence less visited than Andasibe, the open, light forest on the mountainous territory of Mantadia contrasts with the wet forest habitats of eastern Madagascar. This verdant paradise is brimming with epiphytes and orchids of all kinds, lending it a bewitching, tropical charm. Mantadia has similar fauna to Andasibe, though with certain unique features. The resident fauna also includes the small-toothed sportive lemur and the aye-aye, not forgetting secretive carnivores like the fossa, the falanouc (or small-toothed civet), and the fanaloka (or Malagasy striped civet). The indri is certainly present here, but less easy to spot. On the other hand, the ruffed lemur frequently betrays its presence by the loud, shrill cry it uses to communicate with its fellows in other groups. Equally elusive because of the difficulty of getting into the Mantadia forest, the diademed sifaka is an elegant lemur with a white and orange coat, earning its name from the crown of dark hair on its head. After the indri, it is one of the largest of the prosimians, reaching around one metre – including the tail.

Amongst the birds, the red-breasted coua, identifiable by its cherry-red breast, usually chooses a tree fern or a pandanus to weave its bowl-shaped nest out of slender twigs. On the ground, the plant litter is the realm of the ground-rollers. The scaly ground-roller has eyes ringed with pink skin and underlined with a black line behind the eye, while the spotless breast of the slimmer pitta-like ground-roller, contrasts with the dark blue, russet and green of its remaining plumage. Both equally rich in flora and fauna, Andasibe and Mantadia together offer two different facets of the wild world.

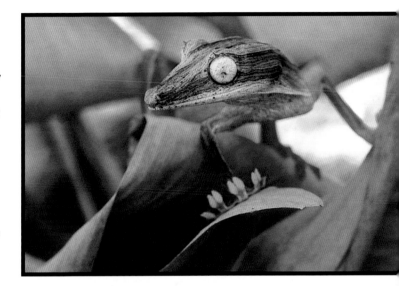

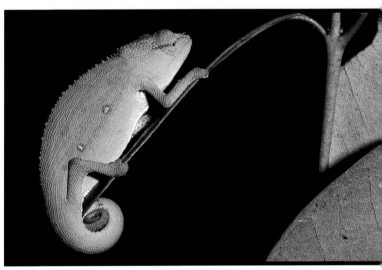

With a little bit of luck and patience, the forest has some interesting surprises in store, as here, with this leaf-nosed vine snake preying on an unfortunate gecko. Harmless to humans, the leaf-nosed vine snake is noteworthy as the female has a leaf-shaped rostrum, while the male has only a pointed nose. There are numerous geckos on the island, many of them endemic like the well-camouflaged lined leaf-tailed gecko, Uroplatus lineatus, (above top), photographed with a macro lens. The same lens was used for this nocturnal encounter with a Petter's chameleon taken with a flash.

The Parson's chameleon is the largest chameleon in Madagascar, possibly in the world, not far ahead of the giant chameleon. These reptiles appeared on Earth during the Cretaceous era. Contrary to what is generally believed, they have only a limited palette of colours, varying from one species to the next, and they change colour not only to blend in with their surroundings, but also to express their emotion – be it desire or fear. When they sleep at night they appear pale and are easy to pick out with a torch. A wide angle lens was used to take this portrait of a co-operative animal.

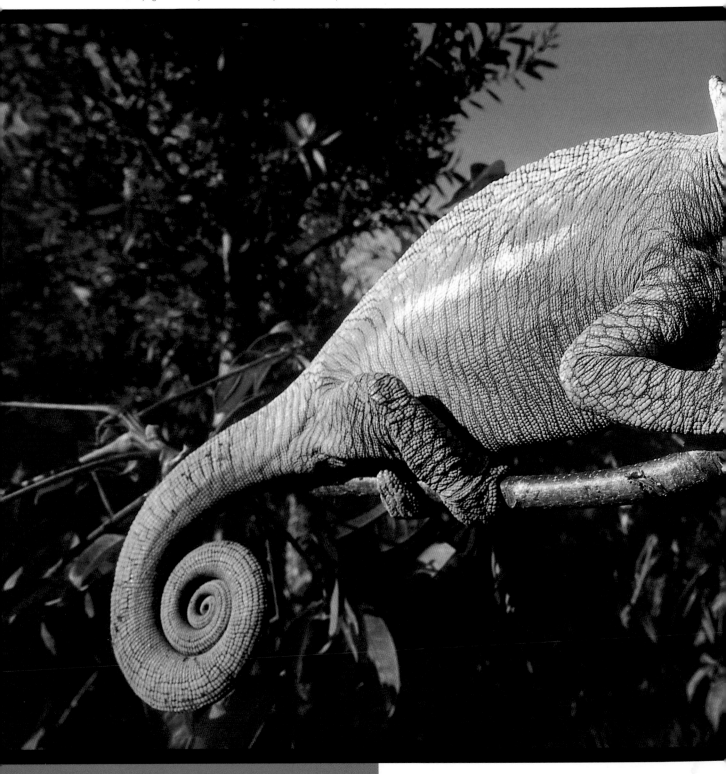

Ranomafana

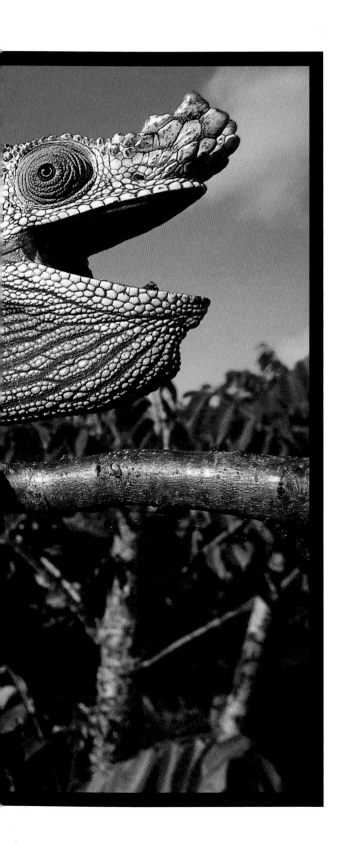

Ranomafana National Park lies in the southeast of Madagascar, in Fianarantsoa province, 60 or so kilometres from the town of the same name. With a very high number of endemic species, the Park is a study ground for many researchers, and since 2003 has had an international centre for research and development. Ranomafana owes its name to the presence of an iron-bearing hot spring whose health benefits have been recognised since the nineteenth century. Opened on 31 May 1991, the Park was set up with the aim of protecting the golden bamboo lemur, discovered in 1986 by scientist Patricia C. Wright and her team. It is one of 12 species of lemur living here. Nestling in the valley carved by the River Namorona as it cuts through the eastern escarpment from the heights of Madagascar's central plateau, the Park's protected space covers around 435 square kilometres, its rugged relief rising in stages from 400 to1,400 metres in altitude. The Namorona has lots of tributaries that rise within the park, irrigating the steep hills and contributing in no small measure to the shaping of their topography. The impenetrability of certain mountainous zones has made it possible to preserve them, but before the National Park was set up, the more accessible parts had been deforested, exposing great expanses of infertile red soil that today make up around a third of the Park's area.

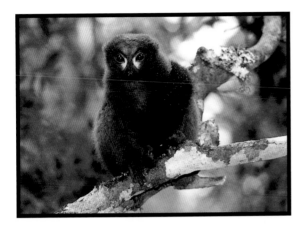

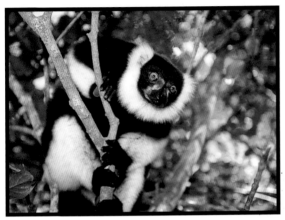

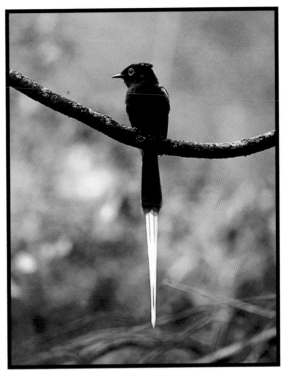

This landscape, shot with a wide angle, illustrates the abundance of the tumultuous waters that irrigate the vegetation and have made it possible to build the sole hydroelectric dam in the south of Madagascar on the Namorona River. A red-bellied lemur, taken using a telephoto, is endemic to certain eastern forests and will occasionally supplement its plant diet with invertebrates. Locally endemic too, the ruffed lemur (above) proved more co-operative, as a medium-long lens was enough to capture its beady orange eye. It is still often hunted for meat or caught alive for a pet. Represented on the island by a widespread sub-species, the elegant Madagascar paradise flycatcher, taken here with the help of a long lens, builds a cup-shaped nest of twigs and moss at the intersection of two branches.

Benefiting from the high rainfall – between 2,300 and 4,000 millimetres a year – Ranomafana's abundant vegetation consists primarily of rainforest. Winding paths, steep and sometimes slippery, make it possible to explore this luxuriant forest, brightened up by the milky flowers of the epiphytic orchids. Here, deadly carnivorous plants, tree ferns with their lacy parasols, and many other unusual varieties of plant life flourish. The bamboo thickets are the most likely place to find the golden bamboo lemur, with a dark brown and orange coat, which eats their stems and leaves. A close cousin, the very rare broad-nosed gentle lemur – thought to be extinct, as it had not been seen from 1972 till the late 1980's – also likes the bamboo. The eastern lesser bamboo lemur is sometimes caught by the Madagascar tree boa that lounges around at night on the ground in loops of gleaming scales. The ring-tailed mongoose threads its way through the shadows of the undergrowth – a small carnivore with a reddish coat. It feeds on the small nocturnal russet mouse lemur and greater dwarf lemurs which it flushes out, and will also raid dustbins.

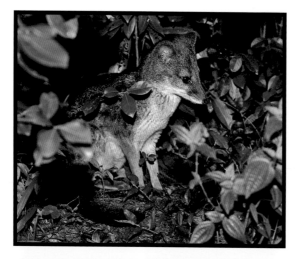

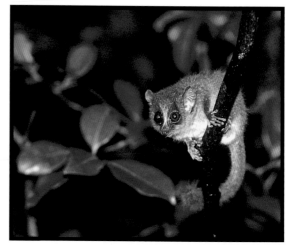

The Malagasy striped civet or fanaloka (top), was taken at night with a medium long lens. This timid animal spends the day in a crack or sheltering under branches on the ground. The tiny russet mouse lemur, weighing barely 50 grams, has been observed attacking insects as big as itself. The streaked tenrec lives in family groups in burrows at a depth of about fifteen centimetres. These were captured on film using a medium long lens, just like the elusive aye-aye (opposite). Nocturnal and solitary, it very rarely puts in an appearance. This highly specialised feeder uses its very thin middle finger to prize out grubs from inside rotting wood. To convey the damp, dark atmosphere of the tropical undergrowth where water splashes from everywhere, nothing beats a wide angle, a tripod – and a long exposure in low light.

The largest of Madagascar's predators, the mysterious fossa, is also present but the vast, overgrown territories through which it moves, together with its twilight habits, make it impossible to observe. Another of the Park's residents is the woolly lemur, active at sunset and just before dawn.

The tangled forest is colonised by 68 species of reptiles and frogs. One of the most attractive frogs is the painted mantella, Mantella baroni, with its yellow and black skin. Amongst several varieties of chameleon are the carpet chameleon, the tiny Brookesia nasus, the short-horned chameleon, and Parson's chameleon, which reaches 60 centimetres. Ranomafana has around 115 species of birds, but they are hard to spot, though they are often heard – especially the blue coua with its highly original, questioning cry. Besides several types of heron, ducks and rails, Ranomafana is home to endemic species of sunbirds, greenbuls, swamp warblers, vangas, fodies as well as a drongo. The wealth of wildlife in Ranomafana is currently generating an increase in tourists. We must hope that the 100,000 or so inhabitants of the villages around the Park will manage to take best advantage of this for the sake of their own future, and that of the island.

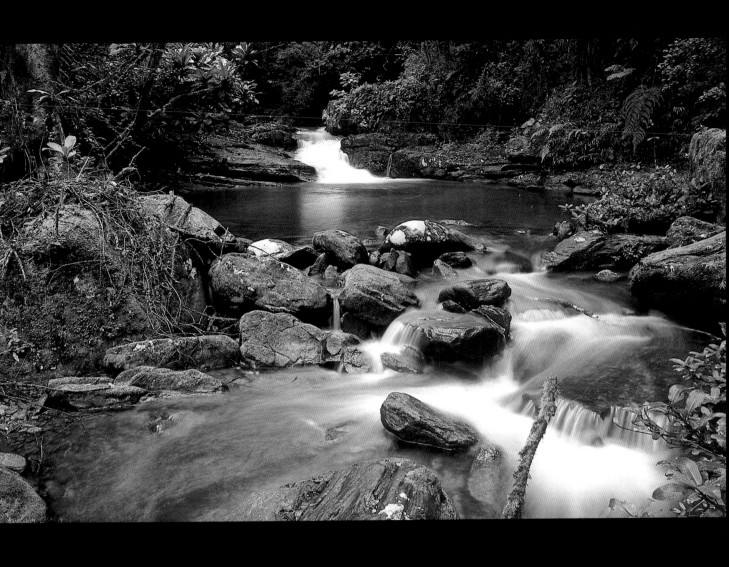

Isalo

The Isalo National Park in Fianarantsoa province was set up in 1962. Lying at an average altitude of 1,000 metres, with an area just less than 82,000 hectares, it covers a Jurassic sandstone plateau with ruin-like reliefs which create some sumptuous landscapes. This mosaic of rocky pinnacles, escarpments, gorges, and plains, sculpted by erosion over millennia, is full of warm pink and ochre hues rendered even more bewitching by the dusk light. It takes several days to explore this geological jewel on foot. Travelling from south to north, the massif presents several curiosities. The triangular gap of the Isalo Window opens onto a vast, grassy savannah strewn with rocks and occasional trees, where the sunset provides an ever-changing spectacle. A few kilometres away, the rock formation called Queen of the Isalo cuts a high profile amidst the sedimentary rocks.

East of the village of Ranohira a track dotted with megalithic monuments leads to the Natural Pool, where a refreshing waterfall plunges into clear water shaded by pandanus. Lined with euphorbia, the track winds along the foot of cliffs peppered with Baras tombs, named after the dominant tribe in the province. Then it joins the River Sable, hemmed with palms, aloes and ferns, and finally arrives at the pool. To get to Monkey Canyon (or Canyon of the Makis), you have to pass over a rugged relief punctuated with a sparse covering of rock-growing vegetation such as the elephant's foot. Early in the morning, you might be lucky and glimpse a ring-tailed lemur.

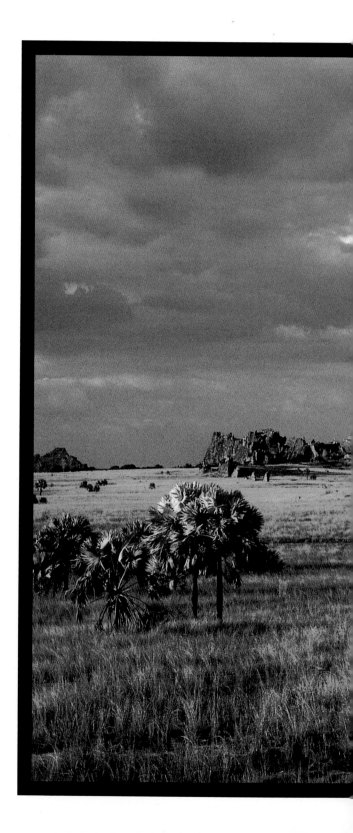

The best time to visit Isalo is from April to October. The massif offers a whole palette of different forms. The light at sunrise or sunset redefines its contours and reveals new harmonies of colours. Looking at this bare, geological environment, it is hard to imagine there are veritable oases of vegetation nestling in the depths of its relief. This is a favoured spot for photographers who are fond of landscapes, where a wide angle lens and a tripod are recommended for optimum results.

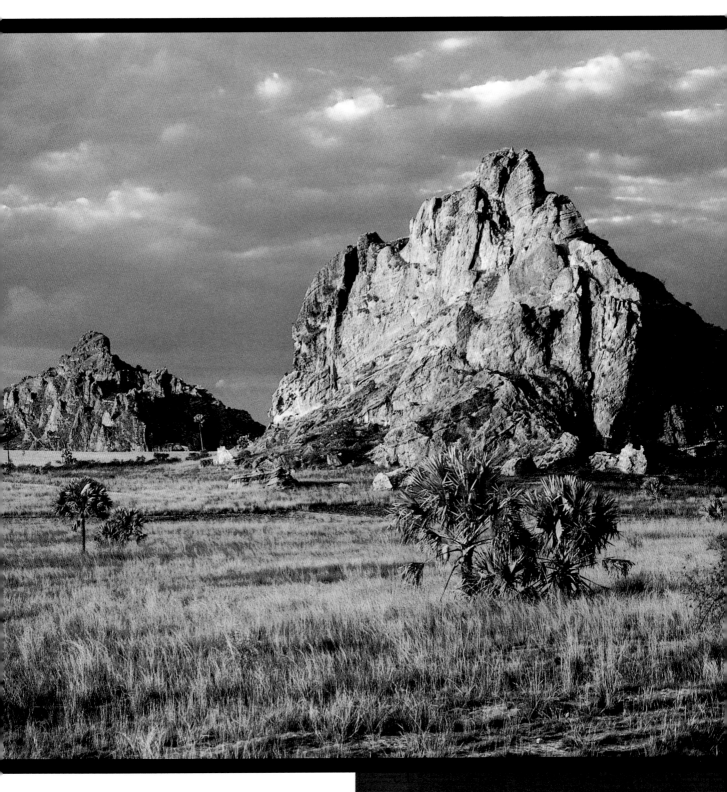

Attractions not to be missed within the massif include the rocky world of the Isalo Window (below) which provides a striking contrast with the profusion of vegetation in Monkey Canyon (opposite page). The silver-barked elephant's foot is a typical plant of arid habitats. All three pictures were taken using a wide angle, ideal for the perspective. A Madagascar coucal (bottom) was taken using a long lens, because even though widespread on the island, the bird is fairly shy.

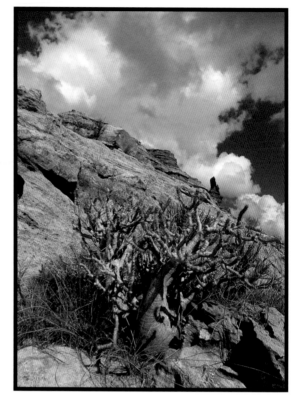

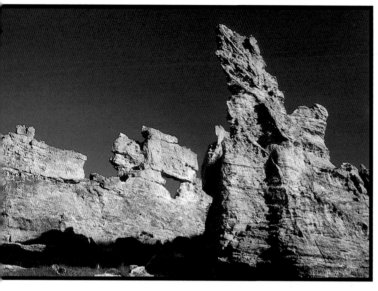

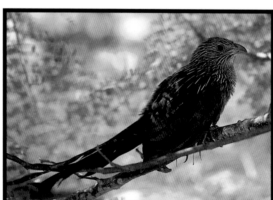

The route offers some magnificent panoramas of the massif, and once you arrive at the canyon, it is a real oasis – a complete change from the rocky world outside. The profuse vegetation forms a thick, glistening green ribbon along the river. Here can be found the endemic fire-resistant tapia trees. A variety of frogs, chameleons, and lemurs are amongst the animals that frequent the favourable environment within Monkey Canyon. The Verreaux's sifaka lives in the gallery forest where it gathers the leaves, fruits, and flowers that form its diet.

Less easily accessible, Rat Canyon has a similar configuration to Monkey Canyon – a relatively broad gorge, narrowing in places to a mere crack, brimming with vegetation where the sunlight barely penetrates. Although extremely rare here, the red-fronted brown lemur can sometimes be glimpsed. In the extreme north of the Park, a visit to the famous Portuguese Cave requires a trek of several days. The cave has traces of past human presence.

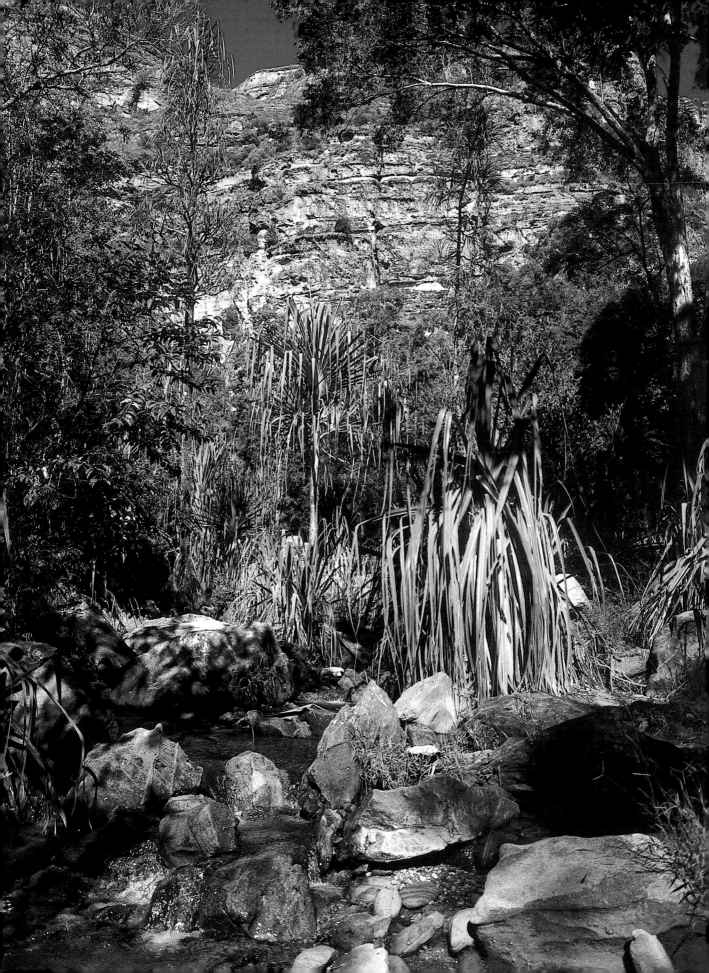

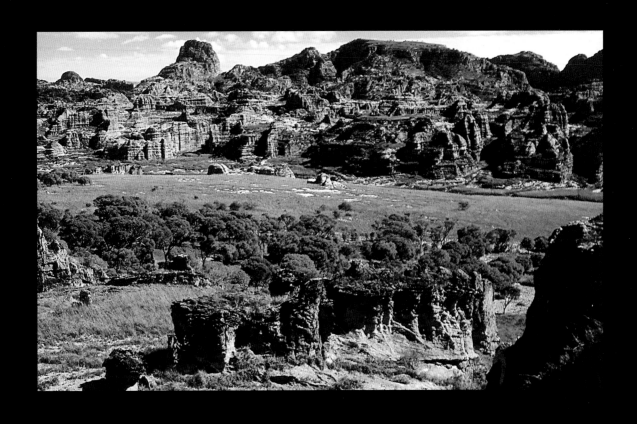
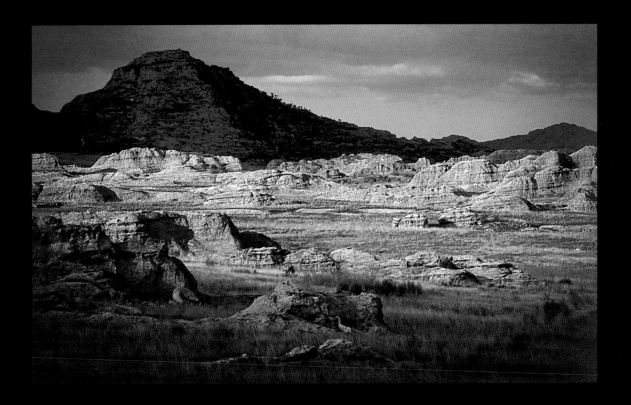

Emerging out of the grassy or sparsely wooded savannahs, the Isalo relief creates surreal landscapes that are best reproduced using a wide angle. The best lenses for taking the nocturnal wanderings of the little russet mouse lemur is either a macro lens, or a medium long lens and a flash. The red-fronted brown lemur (which also lives in some wet forests in the east of the island), is almost entirely arboreal and rarely comes down to the ground, so a long lens is very useful here.

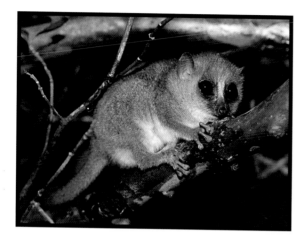

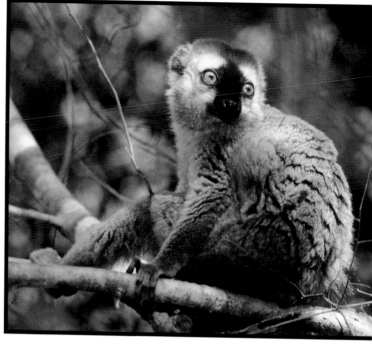

Some architectural features seem to suggest it was occupied by Arabs. It may, however, have provided a welcome shelter for shipwrecked Portuguese sailors, whose ship is said to have foundered on Madagascar's west coast and who were trying to return to one of their trading posts near Taolagnaro (Fort Dauphin). The cave itself is of only limited interest, but the surrounding scenery is breathtaking. Rocky massifs run one into another in a variety of forms and tones that are a constant invitation to feast ones eyes. Locally endemic, the Benson's rock thrush, in its grey and orange livery, can sometimes be seen hopping after an insect on a flat rock. Found nowhere else on the island, Isalo aloes emerge sporadically from the rocks. Just south of the cave, the superb Sahanafo Forest is bubbling with natural springs, and mischievous lemurs from time to time shake its dry branches, sending up a crested coua disturbed in its hunt for food. The Isalo is not a key spot for seeing animals, but its primitive, rocky beauty leaves the visitor with an unforgettable memory of a journey to a breathtaking and unique location.

Although the animals have for a long time been protected in the Berenty Reserve and do not appear shy, this portrait of a ring-tailed lemur was taken with a long lens. The animal was possibly searching the sisal for water trapped in the leaf bases, so it was necessary to react quickly to capture his gaze in this graphic setting. The ring-tailed lemur is probably the most-studied and best known of all the prosimians but outside the Reserve, its survival is threatened by habitat destruction.

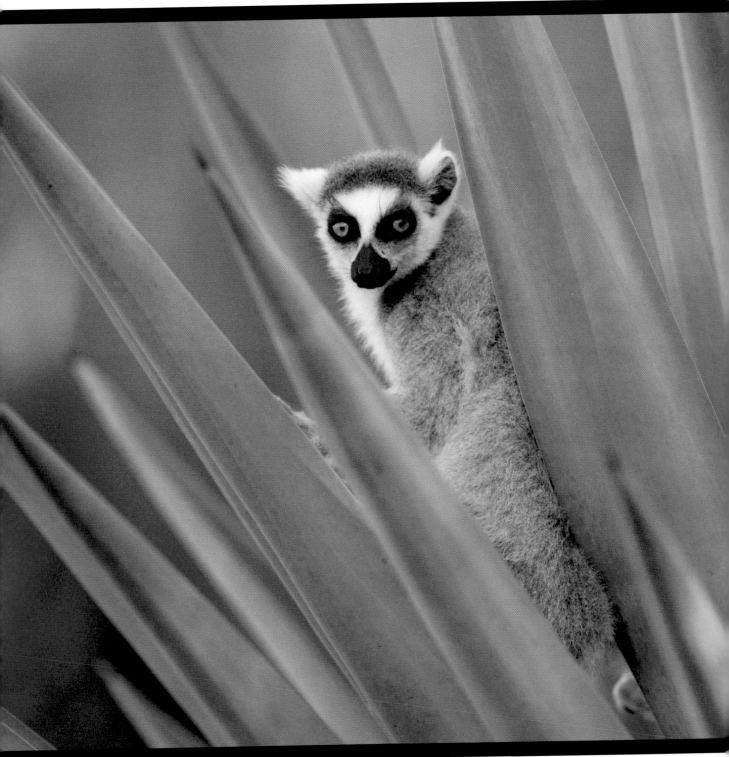

Berenty

Arriving in Madagascar in 1928, the de Heaulme family settled in the southern desert where, after being involved in timber and rubber production, they made a name for themselves running sisal plantations. Sisal is an agave that originates from Mexico and was introduced to Madagascar over a century ago to produce fibres for making ropes and matting. To make room for the sisal plantation, large parts of the gallery forest stretching along the River Mandrare that crosses the reserve were cleared, driving many animals from their natural habitat. However, in 1936 the de Heaulmes decided to protect what was left of the intact land by creating a reserve of around 260 hectares. Located in the heart of an arid region two hours from the road to Taolagnaro (Fort Dauphin), the privately owned Berenty Reserve has today become an unmissable stop on all the tourist circuits, ideal for getting close to certain species of lemurs and observing them under the best conditions. Every year scientists come from all over the world to study these fascinating creatures, among them Alison Jolly, the famous American primatologist specialising in prosimians. Jean de Heaulme, son of the founder Henri de Heaulme, now runs Berenty working in close collaboration with the WWF. The well-maintained, easy footpaths that criss-cross the Reserve make it possible to explore two distinct habitats. The gallery forest which lines the Mandrare River banks is a more open forest and contains a mixture of African hackberry and fig trees, dominated by introduced tamarinds, some of which are now over 20 metres tall. The vegetation of the arid zone is known as the spiny forest. Here, a distinctive deciduous thicket of entwined, prickly stems of Didierea species –

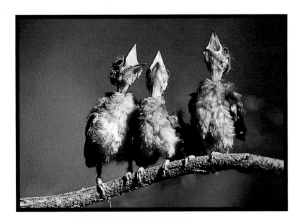

including Didierea madagascariensis, known as the octopus tree from its haphazard branching together – thrive together with euphorbias.

Each of these two quite distinct environments should be visited to observe Berenty's abundant wildlife population. The ring-tailed lemur is Berenty's emblematic animal. With its long ringed tail and its orange eyes, this graceful lemur has no fear of humans and, in the Reserve where it is protected, does not hesitate to get quite close to visitors. Gregarious and territorial, these lemurs always go around in groups, dominated by an alpha female. The Verreaux's sifaka is also well represented, equally as at home in the gallery forest foliage as amongst the sharp thorns of the spiny forest. Mainly tree-living, it performs a ballet-like dance as it moves across the ground, bounding sideways, throwing out its long legs and raising its upper limbs into the air for balance.

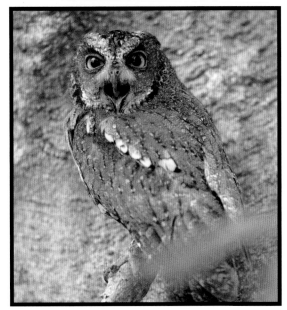

When it comes to photographing birds, the telephoto becomes indispensable if you want to obtain a good picture. The chicks of the Madagascar paradise flycatcher cheeping their heads off would have been much too small with a shorter lens.
The same lens was used to take the loquacious Madagasy scops owl, which perhaps is reacting to being found at its daytime hideaway. It normally spends the day hidden in the deepest depths of thick foliage. The endemic Sakalava weaver was so busy concentrating on building its skilfully woven nest, it barely noticed the photographer's presence. This bird lives in colonies and a single tree may be home to ten or more nests.

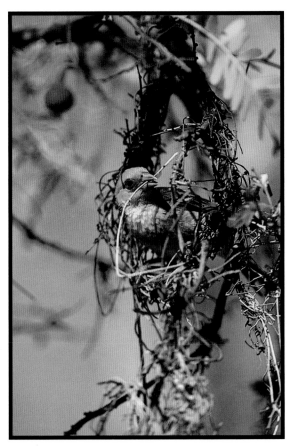

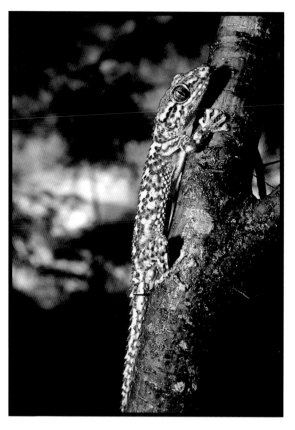

Equipped with small spines on its skin, the Paroedura bastardi gecko can blend in perfectly against some tree barks. When it starts to become active at dusk, opportunities arise to take portrait shots using a wide angle. Thanks to a long lens, some common mynahs, fighting aggressively, have been caught in action with this tight crop. Originating from Asia, this bird was introduced into Madagascar in the late eighteenth century to combat locust invasions. It is now prolific across much of the island, notably in deforested areas.

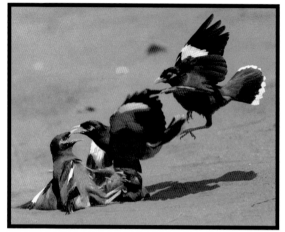

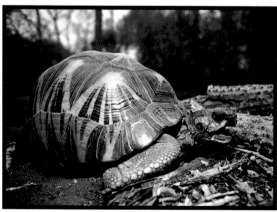

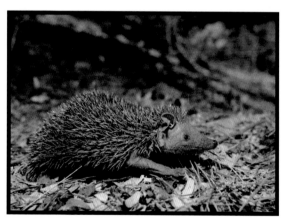

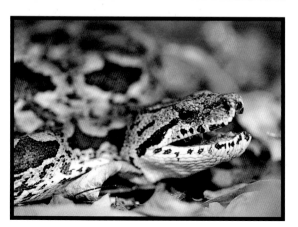

The radiated tortoise, taken here with a wide angle, is a protected species endemic to the island. Just below, the Madagascan boa lets you get quite close to it, particularly during the rainy season when you have the greatest chance of seeing it. Then a medium long lens is enough to immortalise the encounter. However, it is not so easy to spot the lesser hedgehog tenrec. Greedy for insects and fruit, it spends a large part of its time within trees. When food becomes scarce in the dry season, it shelters in a hollow tree-trunk for several months. Not very shy, this one allowed itself to be taken with a wide angle.

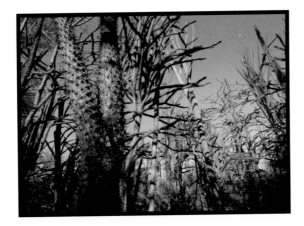

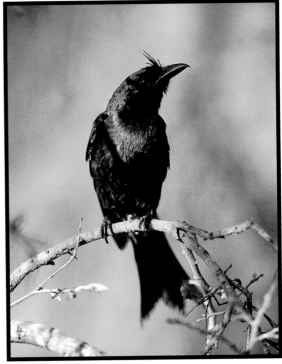

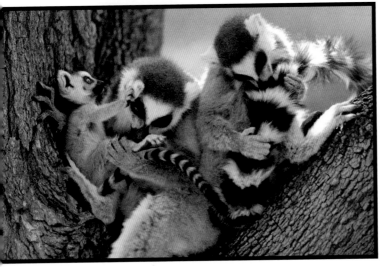

Resembling the arms of an octopus, the form of the bizarre spiny octopus tree is here accentuated by the skywards view using a wide angle. These Didiereaceae are emblematic of the spiny forest that predominates in the south of Madagascar. The ring-tailed lemurs can negotiate the spiny forest and often take refuge there. A family in a grooming session, which helps to reinforce their social cohesion, was taken with a telephoto so as not to disturb the animals. The same lens was used both for the duo perched on an aloe, bathed in the warm evening light, and the crested drongo which seems ready to perform his nasal song or indeed to imitate the songs of other birds.

Berenty is also home to the Madagascar fruit bat, a species of giant fruit bat (or flying fox) that during the day hangs head down from the lower branches of the canopy.

Several levels below, a placid Madagascar ground boa, cousin of the South American boa constrictor, crawls through the undergrowth. It is harmless to walkers, who can safely admire its fine brown scaly skin. Further off, the radiated tortoise with its starburst shell wanders on the carpet of dry leaves, while a giant day gecko, easy to spot in its livery of green with red spots, rests motionless on a plant shoot. Amongst the 96 bird species present, the giant coua, a ground bird – and elsewhere the victim of trapping and hunting – finds serenity here with the ground not too densely covered with grasses. The elegant Madagascar paradise flycatcher is fairly common and an encounter between two males is sometimes an opportunity to watch lightning chases. Just as fast is the flight of the Madagascar sunbird, represented by a locally endemic sub-species. You will need to look around plants in

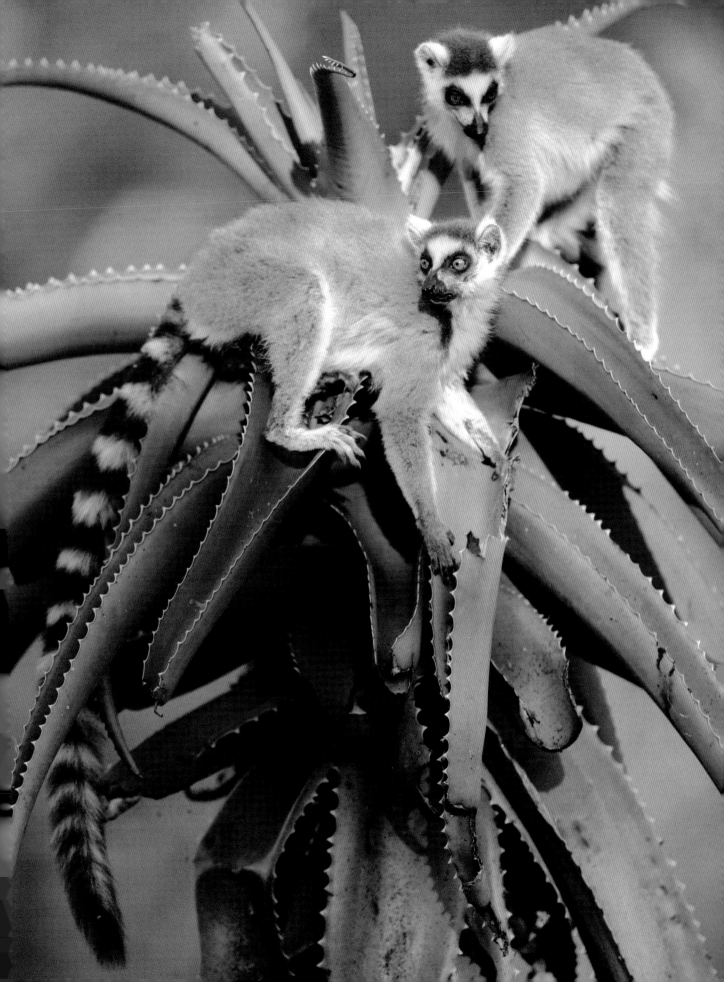

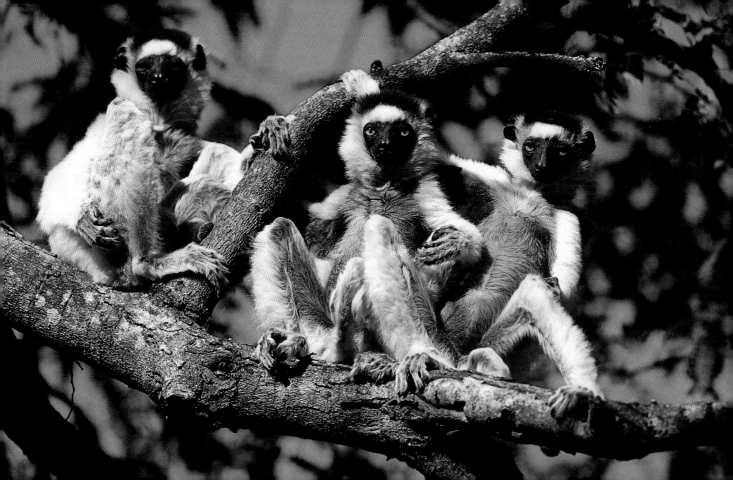

In the dry and slightly cooler season, the Verreaux's sifakas wake up slowly in the morning. After an hour or two, they make their way up to the canopy to sunbathe. Magnificently lit, this is just the moment to take them with a telephoto. The same lens was used to take the giant coua, which rarely flies. It is discreet but not particularly timid, especially when looking for food amongst the leaves on the ground. Taken in the early morning with a wide angle, the River Mandrare that winds through the reserve is bordered with a gallery forest that is home to countless animals.

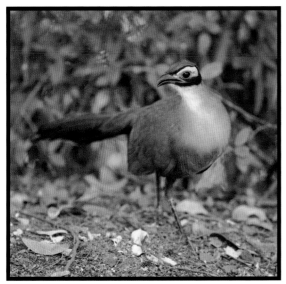

bloom for this little passerine with a fine, curving beak that enables it to sip nectar from the flowers. Plenty of other birds can be seen by day at Berenty, while others prefer to wait for nightfall to make an appearance.

Evening outings sometimes make it possible to find the white-browed owl which, as its name implies, has thick white eyebrows joining together in a V on its forehead. It likes to station itself on a branch overlooking a clearing or a track and eats insects, just like the Malagasy scops owl whose monotonous song resounds for much of the night. At night too, the greater hedgehog tenrec leaves its burrow to look for food – a balanced diet of invertebrates and fruit. Perhaps it will cross the path of the small Indian civet, introduced from the Indian sub-continent and now found throughout Madagascar. Berenty is also a refuge for nocturnal lemurs, like the grey mouse lemur.

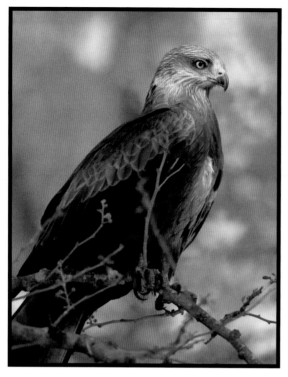

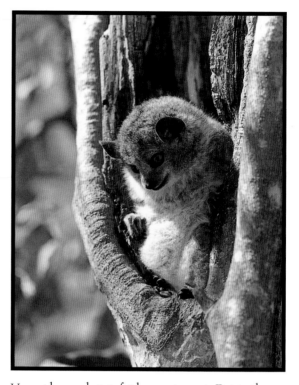

The kite prefers wetter habitats where it can be observed and, as here, photographed using a telephoto. This bird is an opportunist feeder, either scavenging or preying upon rodents and chicks. The white-footed sportive lemur is endemic to south Madagascar and, although nocturnal is easy to observe in Berenty where it colonises both the gallery forest and the spiny forest. A medium focu lens is sometimes long enough to take its portrait. The highly sociable Verreaux's sifaka is leaping forward here instead of making its more usual sideways movement. The quick reactions of the photographer equipped with a telephoto have made it possible to capture the animal in mid leap.

Very widespread, it is fairly easy to spot. But in the dry season, after having built up a third of their body weight in fat reserves, males and females separate, retiring to the inside of a tree-trunk where they will spend five months sleeping. Less easy to spot in the dark, the fat-tailed dwarf lemur also stocks up reserves of fat in its tail, to take it through the dry months during which it stops all activity. Lastly, as soon as darkness falls, the white-footed sportive lemur comes out of its daytime lethargy to an accompaniment of noisy cries. It is found in both the thorny bush and in the gallery forest. The evening is also a good time to observe the many chameleons, which stay up in the canopy throughout the day, including the warty chameleon and the carpet chameleon. Besides the natural habitats which can be explored along easy, flat paths, Berenty has a specially planted collection of local xerophytic plants adjacent to the accommodation area. The Berenty Private Reserve may not offer adventure, but it does guarantee you will see certain animal species, with the possibility of taking some memorable pictures.

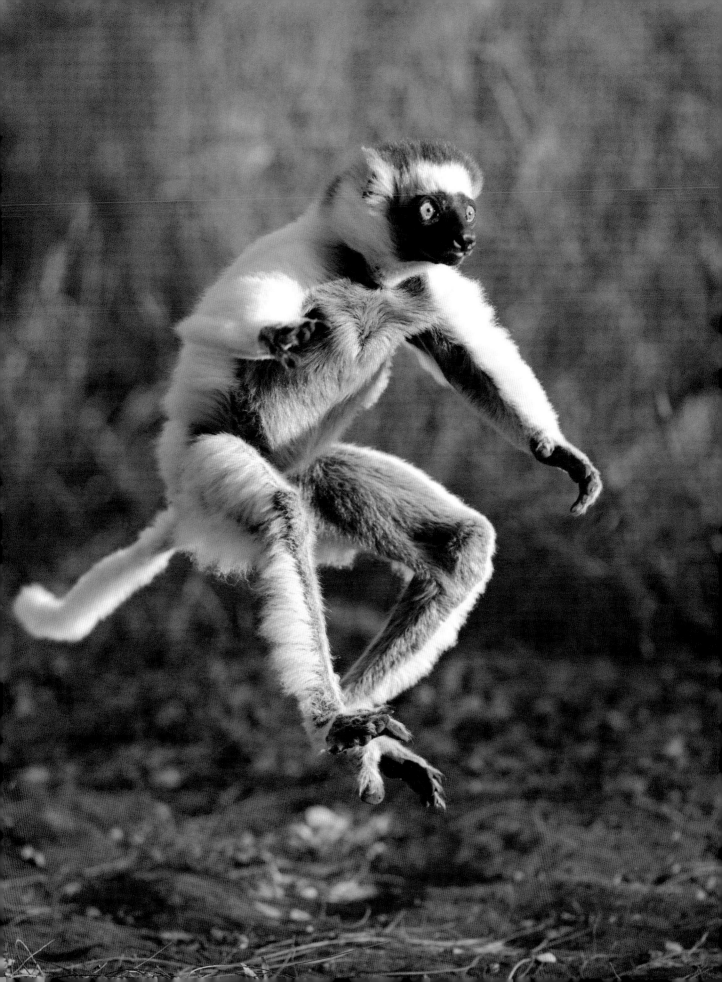

Baobab Avenue Kirindy

On the edge of Marovoay village, 20 kilometres from Morondava on Madagascar's west coast, and heading out towards Belo-sur-Tsiribihina, stands the famous avenue of baobabs. Like some royal drive it is one of the emblematic images of the island. Magical at sunrise and sunset, this majestic avenue is the most-visited and most-photographed spot in the country. Endemic to Madagascar, these baobabs, which reach over 30 metres in height, are the tallest species. Their scientific name *Adansonia grandidieri* is derived from the naturalists Michel Adanson and Alfred Grandidier. The surrounding countryside abounds in these giants, several centuries old, whose trunks resemble elephantine feet and contrast with the delicate water lilies that brighten up the marshes in the rainy season.

A few tens of kilometres away lies the Kirindy-Mitea National Park, on the land of a former private forest reserve administered by a Swiss commercial forestry company. But through sustainable management of its resources Kirindy has escaped massive deforestation. The dry and deciduous Kirindy Forest rises out of the sandy soils on the western coastal plains. Made all the richer by the presence of three of the seven species of baobabs found in Madagascar, it is criss-crossed by footpaths that make it easy to explore the rich flora and fauna. Renowned not only for its precious woods and its medicinal plants, Kirindy Forest also has a reputation as a Mecca for wildlife observation in the west of Madagascar. It is one of the few sites where you can see the

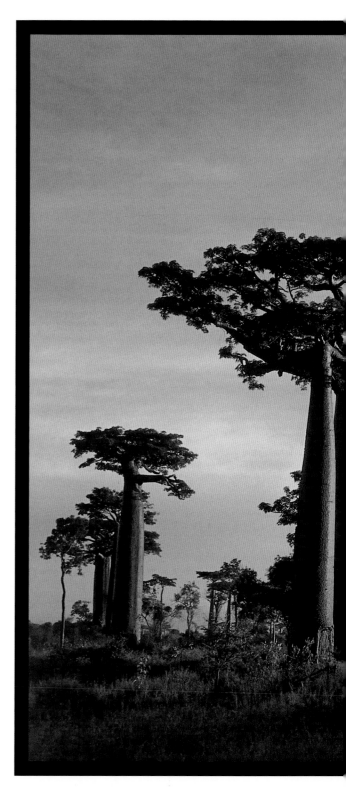

The low angled light at either end of the day lends a certain majesty to the avenue of baobabs. Still numerous in the surrounding countryside, these giant trees stand like sentinels posing forever before the photographer's wide angle. Lovers of dry climates and arid soils, these trees are emblematic of the region and very widespread. However, the proximity of water – whether crop irrigation or marshes – is unfavourable for them.

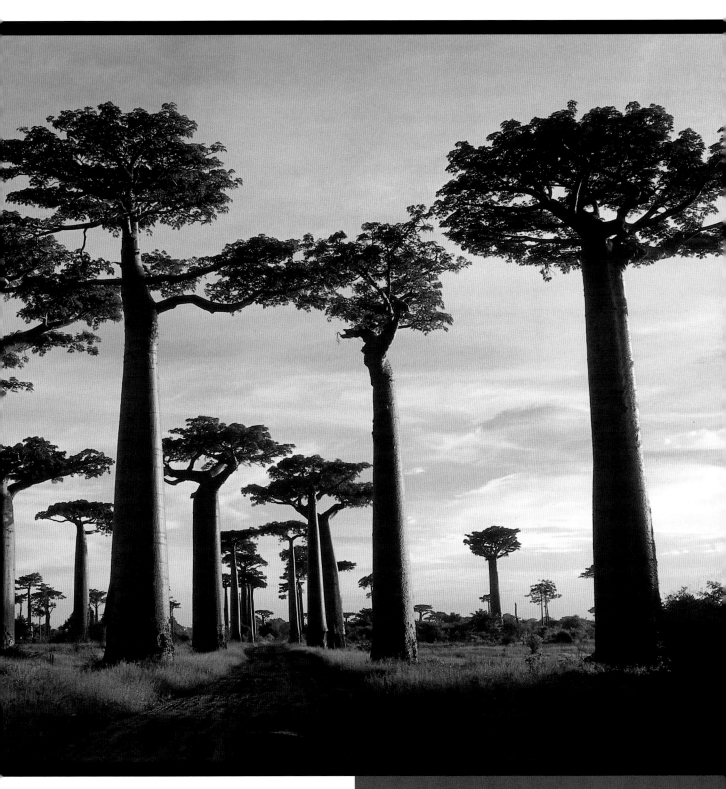

A long lens was needed to ensure a mother Verreaux's sifaka and her baby were not alarmed. Barely a few weeks old, this sole offspring, born after five months' gestation, will not become a parent until it reaches five or six years old. Taking refuge all day in the hollow of a tree-trunk, the red-tailed sportive lemur, estimated to have quite a high population within its distribution area, sometimes provides a meal for the Madagascar long-eared owl or the fossa. Hidden in the shadows, photographing it needed a long lens mounted on a tripod, combined with reflectors to beam light into the crack.

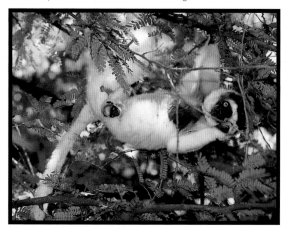

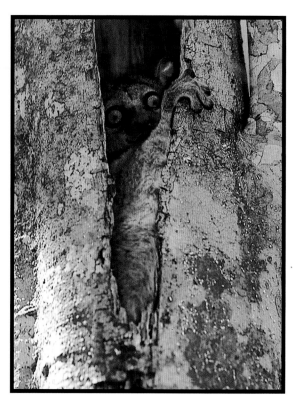

giant jumping rat and the pygmy mouse lemur, both endemic to the region, as well as the Madagascar narrow-striped mongoose. The strange fossa, a mammalian predator halfway between a feline and a canine, is easier to spot here than elsewhere. Other species of mouse lemur and dwarf lemur, and the flat-tailed tortoise (Madagascar's only freshwater tortoise), are amongst Kirindy's curiosities. This is also home to reptiles – geckos, chameleons and snakes of all sizes – in bright or camouflage colours, all harmless to visitors. The Verreaux's sifaka is less discreet as it propels itself by long front arms, performing a graceful aerial ballet up amongst the branches. By scanning the ground, you may spot one of several tenrec species which live in Kirindy. Up above, the warm air quivers with the flight of 40 or so bird species, including the crested coua, Madagascar cuckoo roller, sickle-billed vanga, and Madagascar paradise flycatcher – as well as birds of prey like the banded kestrel and Frances' sparrowhawk. The rich assemblage of wildlife, and the awesome avenue of baobabs, make Kirindy well worth a visit.

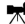

The photographer has used a medium-long lens to shoot a greedy red-fronted brown lemur, caught stuffing itself with papaya. Fruit forms the greater part of its diet, supplemented from time to time with leaves and a few invertebrates. This lemur is also present in wet forests in the east of Madagascar, proof of its incredible ability to adapt to different conditions.

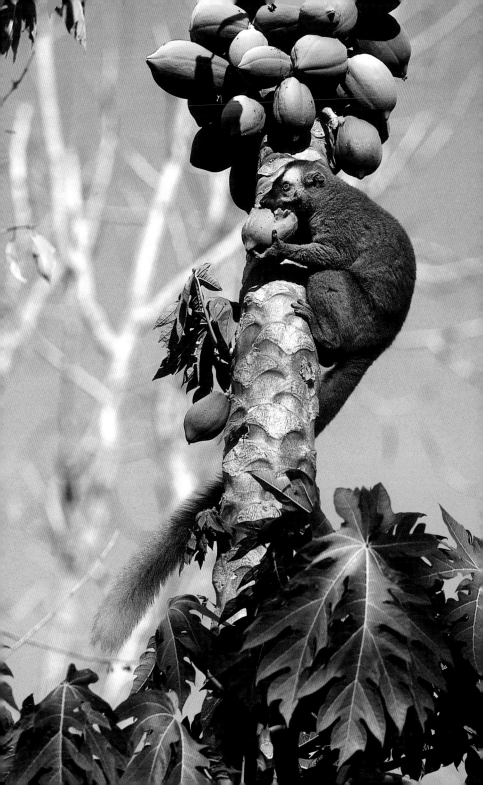

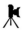

This view of the Bemaraha tsingys, around Andamozavaky, was taken with a wide angle. For those who appreciate beautiful images and beautiful lighting, this sort of site often needs an advance recce to find out the best spot to take it at sunrise or, as here, sunset. Remember also to allow for the time it takes to get there, so as not to miss the ideal shooting moment. The footpaths are sometimes tiring and the sun sinks below the horizon quickly in the tropics.

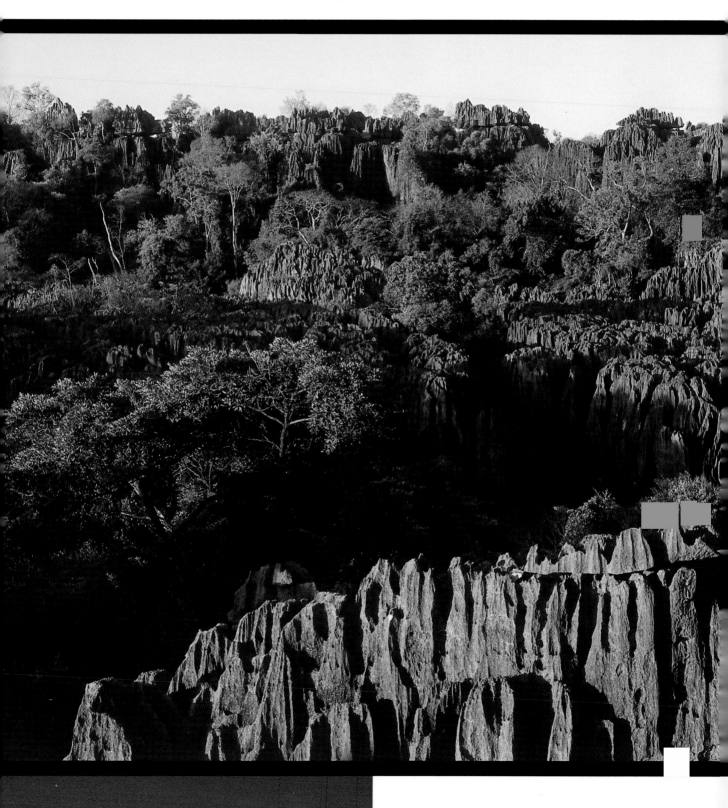

Bemaraha

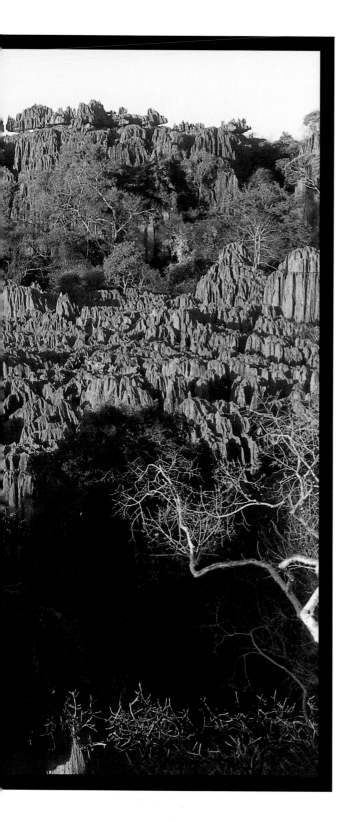

The Bemaraha plateau lies in central western Madagascar, within Mahajanga province. It has enjoyed protection since 1927, long before it gained the status of Tsingy de Bemaraha Strict Nature Reserve and was listed by UNESCO as a World Heritage site in 1990. In 1998, the government decided to open the south of the massif, where the National Park had just been set up, to tourists; until then it had been reserved for scientists alone. It occupies around 72,000 hectares out of a protected area totalling over 150,000 hectares – in other words, one of the largest conservation areas in Madagascar. There is no paved road here from the south, so you have to endure long hours of rough tracks to reach Bekopaka, the village closest to the entrance to the Park. Visitors are allowed into Tsingy de Bemaraha National Park only between May and November.

The formation of the tsingys dates back some 160 million years, shortly after Madagascar broke away from the African continental plate. The west of the great island was submerged under the sea; corals formed which, together with the shells of marine animals, built up to form sediments that became compressed to form layers of limestone.
After tectonic movements raised these strata above sea level, wind and rain gradually eroded them to form the jagged relief of pinnacles and ridges we see today. Forming the massif's natural southern boundary, the River Manambolo, flowing into the Mozambique Channel, has carved out spectacular gorges through the heart of a dense, semi-wet forest alternating with dry, open vegetation. Now and again, you can spot here a Decken's sifaka waking up with the sun lighting its face.

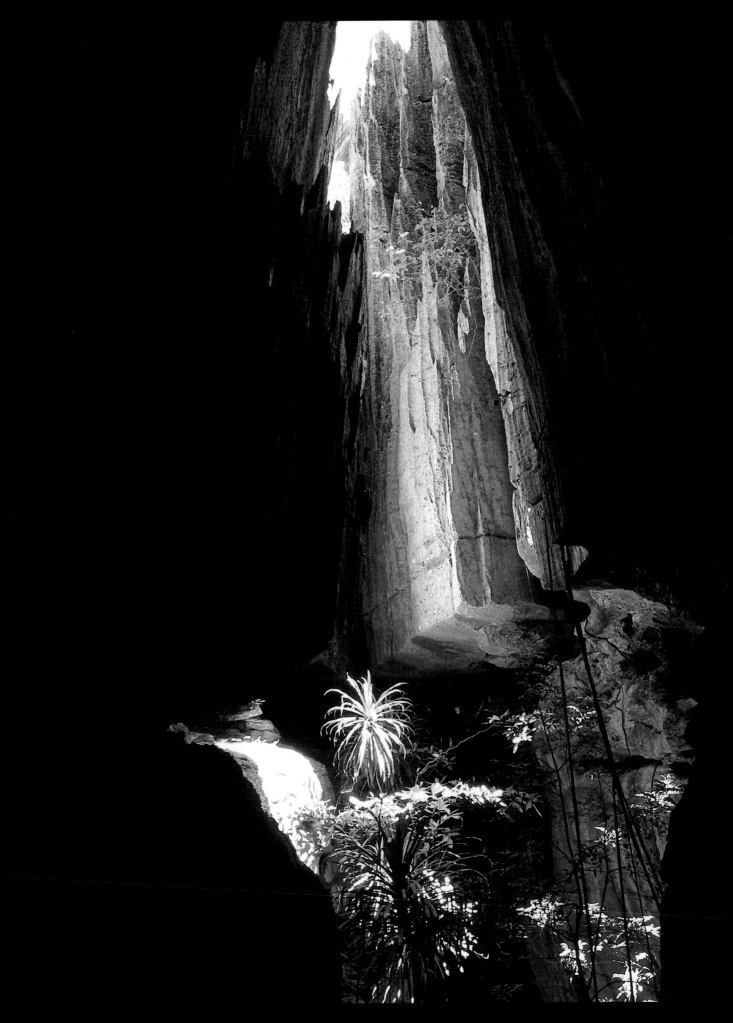

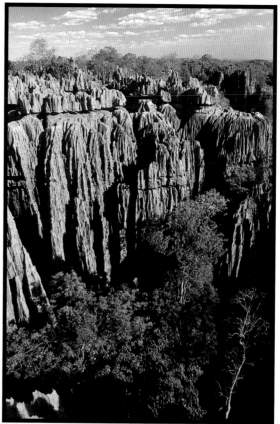

The morning is the best time to glide across the water in a dugout canoe, admiring the tall, chalky-coloured cliffs protruding from the plant cover. The cliffs are hollowed out by caverns, where colonies of bats have made their homes, and some are also the site of ancient Vazimba burials. With a great deal of good luck, you may see the extremely rare and endemic Madagascar fish eagle, whose small numbers are threatening its survival. The site is also ideal for seeing Nile crocodiles.

Amongst the 90 bird species present, the endemic Madagascar wood rail and rare Sakalava rail also frequent the riverbanks. Located in the south of the Park, the small tsingys – so called because they do not exceed 20 metres in height – are pierced with numerous caves decorated with amazing karstic formations. Further north, the region of the tall tsingys measuring on average from 50 to 60 metres, is considerably harder to get to and requires quite a lot of effort. Steep paths, ladders, and suspended walkways are unavoidable to get to the viewpoints and explore this vast network of crevasses and fluted pinnacles. The tsingys plateau is characterised by a veritable jigsaw of vegetation. Its forest cover, generally semi-deciduous, gives way in places to savannahs where the endemic traveller's tree grows – often referred to as a palm but, in fact related to the banana. Elsewhere, the plant life benefits from damp conditions, thanks to the rainwater retained in the

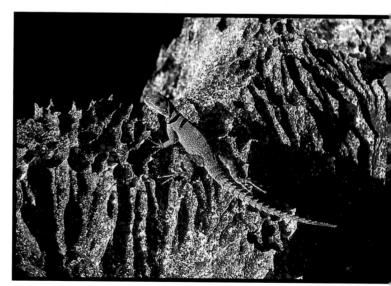

To photograph an island of vegetation in the bottom of a crack in the rock like this (opposite), it is best to wait for the sun to reach its zenith, as otherwise the light does not reach down into the interior of the cleft. A wide angle is recommended for the karstic peaks, into the heart of which plants creep in search of water and coolness. Shot with a telephoto, the Madagascar fody is a male in mating plumage. Outside the mating season this small seedeater's livery is greenish-brown instead. A medium long lens was used to take a small Oplurus iguana, bathed in warm sunlight, contrasting with the eroded rock.

Taken with a telephoto, a Madagascar long-eared owl, concealed inside a forest pocket within the heart of the massif, was waiting for nightfall. This is a quite widely spread species endemic to the island. The same lens was used for the Madagascar pygmy kingfisher on the lookout for prey that it captures during a brief flight, and then returns to its perch to feed. The red-fronted brown lemur is one of the 11 species of lemur present in Bemaraha. Its expression of curiosity has been captured with the help of a long lens, just like the acrobatics of this Decken's sifaka below. Still not very well known, this bounding sifaka with a thick, ivory-coloured coat is comparatively easy to find in the Park.

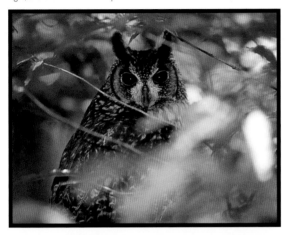

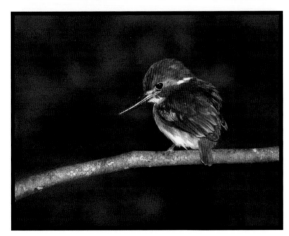

depths of the canyons, which makes Bemaraha a vital source for the whole region. Flame trees flourish naturally here, their scarlet flowers brightening up the fields with their limestone formations – known as lapies – at the end of the dry season. This tree originates from Madagascar, and has been exported to tropical regions worldwide, where it is cultivated as an ornamental tree. Around 85 percent of the flora in Bemaraha is endemic to the massif.

Apart from the tsingys plateau, dotted with commiphora and aloes, Bemaraha has savannahs and lakes that greatly increase the richness of its environment, and create many habitats favourable to wildlife. The small lakes that dot the reliefs are a refuge for tortoises, as well as the Madagascar jacanas and Humblot's heron.. Amongst the plant litter, the spiny chameleon is a miniature monster, with dorsal crest spines and bony excrescences around its head, and is a master of disguise. One of Bemaraha's 50 or so species of reptiles, it is endemic and lives more in the north of the massif. An endangered species whose survival was threatened by illegal trafficking, it now figures in Appendix I of the CITES (the Convention on International Trade in Endangered Species of Wild Fauna and Flora) and thus benefits from the highest degree of legal protection. Slightly less rare, the western grey bamboo lemur haunts the quivering branches. Finding no bamboo here, it feeds on other plants, thereby differentiating itself from its cousin in the eastern rainforests, which is strictly dependent on this tropical grass. Ten or so other species of lemur discreetly frequent the Park's forests – amongst them, the fat-tailed dwarf lemur, Cleese's woolly lemur, and Coquerel's dwarf lemur – all nocturnal trapeze artists. The unusual beauty of Bemaraha's scenery is fascinating and the Park's flora and fauna are no less an encouragement for the visitor to linger.

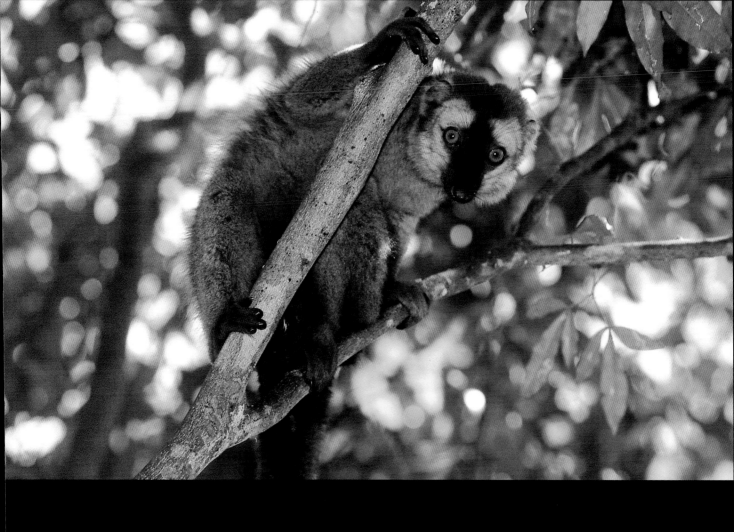

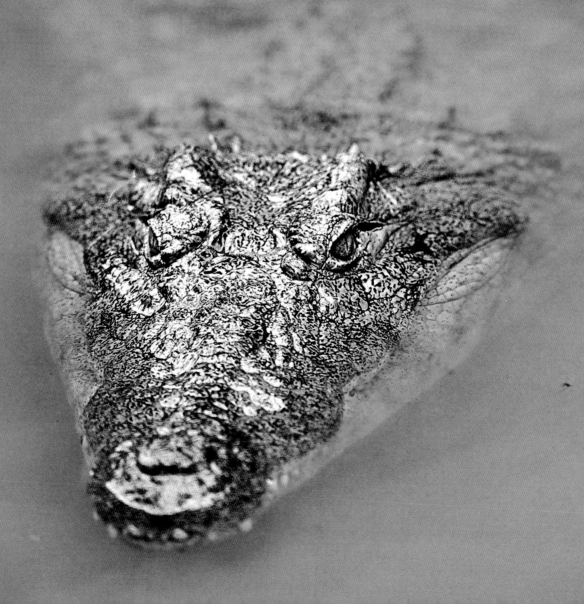

Ankarafantsika

In the heart of Majunga province in north-west Madagascar lies the recently-established 130,000 hectares Ankarafantsika National Park, incorporating the Ampijoroa Strict Nature Reserve, of which only 20,000 hectares are accessible to visitors. The park is home to a centre run jointly by the Madagascan Government, the Jersey Wildlife Preservation Trust, and the WWF, who are managing Project Angonoka, a programme involving rearing, reproduction, and re-introduction to safeguard two species of extremely rare and seriously endangered tortoises: the flat-tailed tortoise and the ploughshare or angonoka tortoise. Located on a limestone plateau of both continental and oceanic origins dating from the Cretaceous era, at an altitude of up to 330 metres, the park consists of a patchwork of dense dry forest, degraded forest, and savannah. Here, over 92 percent of the trees and nearly 85 percent of the herbaceous plants are endemic. Ankarafantsika has a major network of watercourses that feed the whole of the Marovoay rice-growing region. Most of the rivers empty into lakes, where Nile crocodiles and freshwater turtles abound and the margins are fringed with raffia palms.

Low in altitude, the relief is marked by the presence of rocky bars with a southwest/northeast axis, from which sprout elephant's feet and aloes. The well-lit undergrowth, tangled with lianas, is threaded with footpaths, for once easily walkable, which allow you to explore the park's various centres of interest. The Coquerel's sifaka, a trapeze artist with a russet and ivory-coloured coat, inhabits the Park, where its population density is said to be around 60 individuals per square kilometre. Sadly, there is a much slimmer

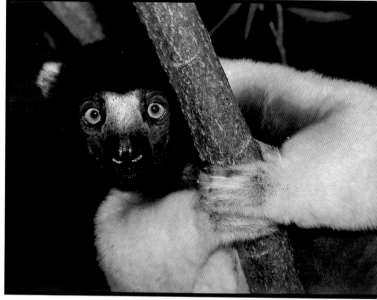

The Nile crocodile is one of the 70 species of reptiles noted in Ankarafantsika. At home in the lakes, it eats mainly fish in the absence of the large mammals it finds on the neighbouring African mainland. Here it was photographed using a long lens. Taking refuge in the depths of the vegetation, flash was needed to capture the surprised and curious gaze of this crowned sifaka, using a medium-long lens. This rare lemur is not actually found in Ankarafantsika, but whilst exploring this part of the island you may get the chance to visit the coastal area where it occurs, particularly in the heart of the forest on the east shore of Bombetoka Bay.

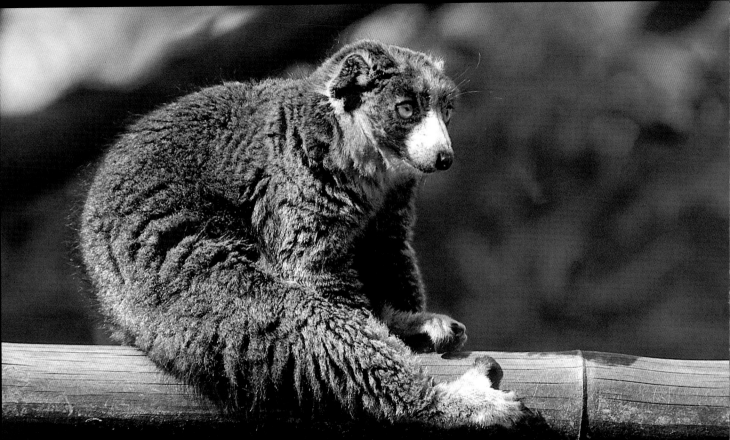

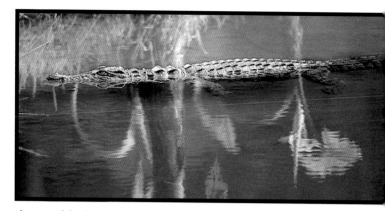

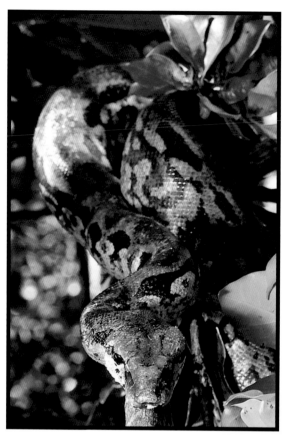

You are most likely to see the mongoose lemur in the Ampijoroa Reserve. It usually lives in small groups consisting of monogamous pairs and young. Originally from northwest Madagascar, it has been introduced onto several of the islands in the Comoros archipelago. Here it was taken using a medium long lens. An affable boa, one of the three Madagascan boas, is more impressive than dangerous. This one allowed its portrait to be taken with a wide angle without any hint of aggression. This Nile crocodile is crossing a small lake from one bank to the other under the gaze of a medium-long lens.

chance of finding the Milne-Edwards sportive lemur with its brown eyes and backwards-folded ears. Ankarafantsika is also the sole protected refuge of the mongoose lemur. Like many other lemurs, when it wanders outside the Park into adjoining deforested areas it may fall victim to hunters. Once night has fallen, the western woolly lemur, fat-tailed dwarf lemur, grey mouse lemur, and golden brown mouse lemur become active. The latter was only observed for the first time a few years ago, near Lake Ravelobe, hence its Latin name Microcebus ravelobensis. The lake is a good place to see Nile crocodiles. Ankarafantsika is also home to plenty of other inhabitants, in particular 129 species of birds. Amongst the most widespread of these is the red-capped coua, with its harmonious brown and garnet plumage; the greater vasa parrot, with dark brown plumage tinged with grey; and the rufous vanga, with a black head and white underbelly. Less common are the white-breasted mesite, with reddish eye patch, and the striking Van Dam's vanga, with black, grey, and white plumage. There is also the flamboyant Madagascar pygmy kingfisher which apart from invertebrates will also attack small reptiles such as chameleons, geckos, and lizards. There are some 70 species of reptiles present in the National Park. The Ankarafantsika complex of protected areas is still home to one of the most precious examples of deciduous forest, and there are many riches still waiting to be discovered.

Lokobe

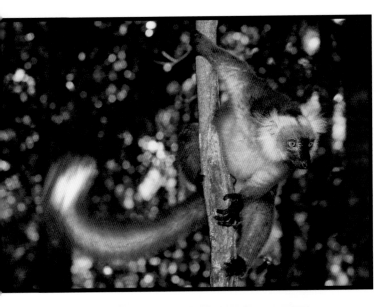

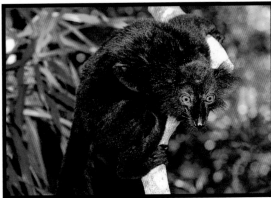

A medium long lens on a tripod and a slow shutter speed captured the movement of this female black lemur (top) leaping from branch to branch, and the same line-up was used for the male (above) in its jet-black livery. On the other hand, it took a telephoto to shoot the mother and her baby. The black lemurs' mating season is April to May; each female produces only a single baby, usually born between late August and early October, after just over four months gestation.

The 74-hectare Lokobe Special Reserve is the only protected area on the paradise island of Nosy Be. Tourist access is restricted to a buffer zone, itself rich enough not to disappoint. Comprising one of Madagascar's last original coastal forests, Lokobe is covered in a dense tropical forest known as 'sambirano'. This is a seasonal wet forest, an intermediate vegetation type between the eastern rainforests and the deciduous forests of the western massifs. Confined to the northwest of Madagascar, the sambirano is typified by a high rate of endemism. The jungle canopy at Lokobe reaches a height of 35 metres in places, and the black lemur is its undisputed monarch. Males are black all over with wine-red glints, while females have a hazel-coloured coat. Once night has fallen, the black lemurs give way to the grey-backed sportive lemurs that emerge from their daytime hideaway and are relatively easy to see. While they go in search of food, the Madagascar long-eared owl is watching out for an unwary frog to snatch in its talons. The Reserve also protects a mysterious resident: the Madagascan flying fox, which is none other than a gigantic, endemic fruit bat. Sometimes, in the heat of an emotion, the panther chameleon found here will treat us to the spectacle of its colourful metamorphoses. The geckos are no less well represented with the Uroplatus henckeli and Uroplatus ebaunii. From the top of a tree, a Madagascar blue pigeon flies off, identifiable by its eyes ringed with red and the red feathers beneath the tail. On the forest floor, the hook-billed vanga is looking for butterfly cocoons to make its nest more substantial. The Lokobe Reserve may have only a small area open to visitors, but it nonetheless offers a most rewarding experience for any naturalist.

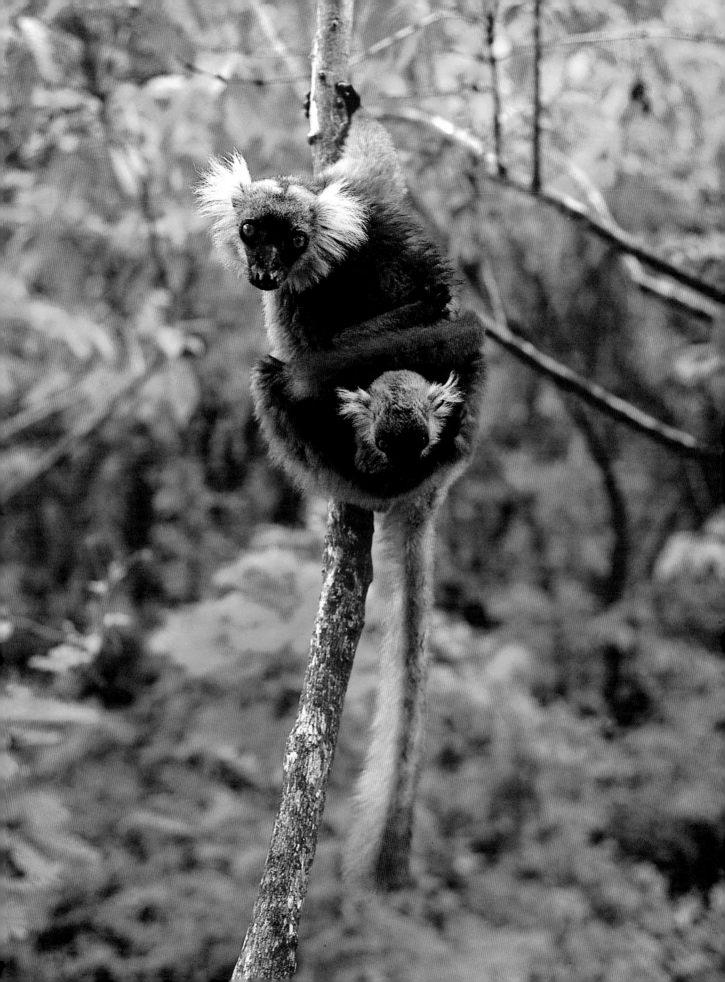

To get from one pocket of forest to another, the crowned lemurs do not hesitate to use the sharp ribs of the tsingys, at the risk of encountering a bird of prey, the mere shadow of which will raise loud alarm cries. But in Ankarana, the crowned lemur falls prey more often to Nile crocodiles. Photographed here using a medium long lens, this little lemur lives in groups, most often of five to ten individuals, which communicate by grunting.

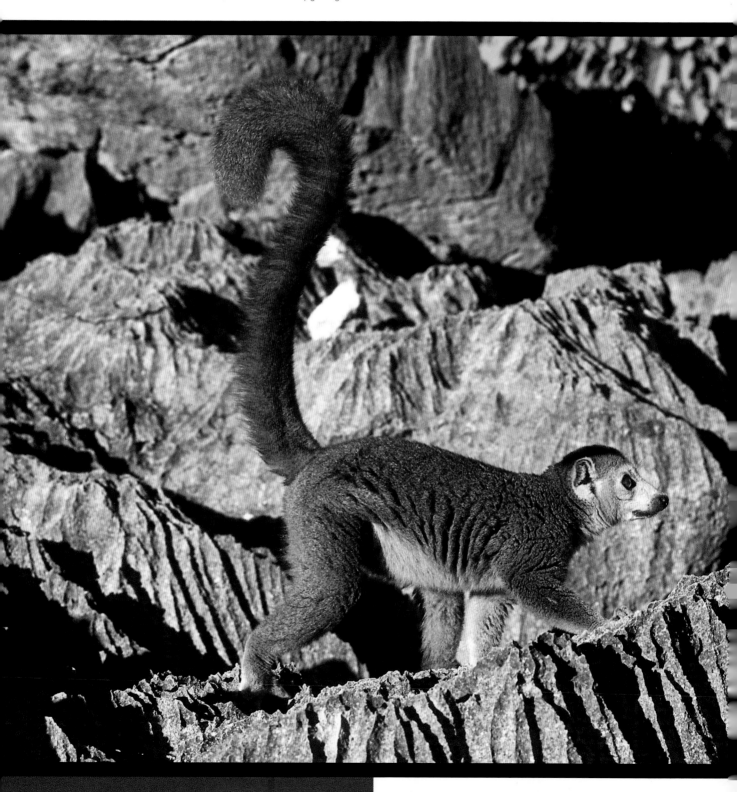

Ankarana

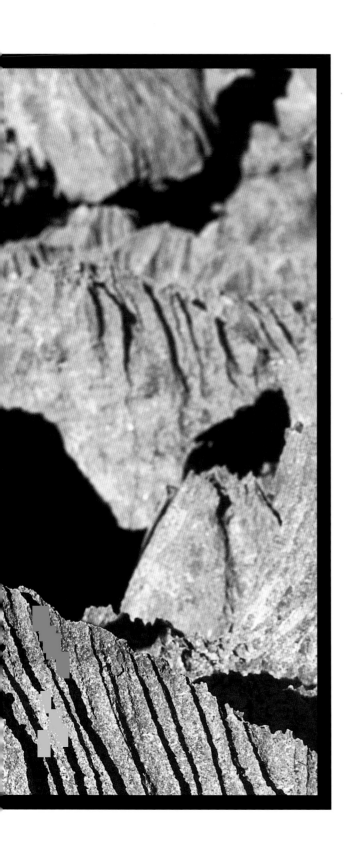

Between the town of Ambilobe and the Amber Mountain National Park, in the extreme north of the country, Ankarana Special Reserve covers a territory of just over 18,000 hectares of the massif of the same name, bordered to the west by a vast dry savannah. Hard to get to, barely studied by scientists during the last 20 years, and little visited by tourists, Ankarana has far from revealed all its mysteries and riches. Yet it is one of the strangest and most fascinating places on the island with a host of limestone swords, sharpened by the rains draining off them since the dawn of time, reaching for the sky. These tsingys are one of the Reserve's principal attractions. Within the heart of their deeply incised relief thrive pockets of primary jungle tangled with vines, home to numerous primates. Towards the surface of the plateau is a forest, consisting of elephant's foot and euphorbia, plus trees with precious wood such as the Madagascar rosewood and ebony, long coveted by the lumberjacks. As is often the case in Madagascar, a large part of the flora is locally endemic. Apart from the tsingys, Ankarana is renowned for its extensive cave system, some of which offer a grandiose spectacle. After the plateau was formed its perimeter was sealed by basalt flows which captured the rains, damming underground rivers which gradually eroded away the soft limestone. This resulted in the creation of dream-like illusions of dark cathedrals. The largest of all

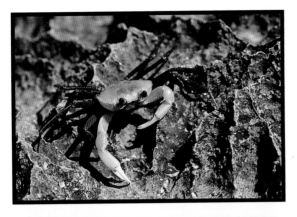

Photographed using a macro lens, Ankarana's tiny cave-dwelling crab appears only in daylight during the rains. The main problem is getting down low enough without cutting yourself on the razor-sharp rocks. One of the massif's numerous caves has been taken in the middle of the day so that the sun would bathe the sculpted walls. The picture was taken on a tripod, using a slow shutter speed, and a wide angle to make the most of the natural light. The Petter's chameleon was taken at night using a 105mm macro. The green colouration, as here, is most common in males, but exceptionally they may exhibit yellow, red, and blue marks. A wide angle lens was essential to show the vegetation surrounding Green Lake nestling in the depression.

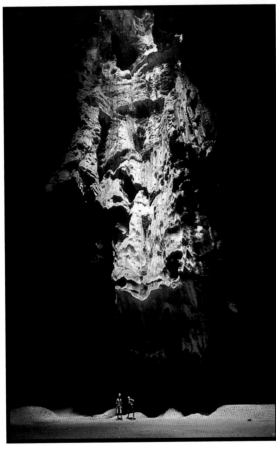

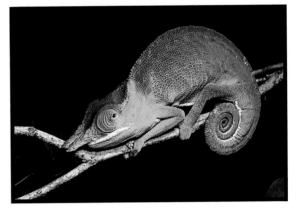

is at Andrafiabe, on the massif's western slopes. It is several kilometres long and includes an impressive network of galleries. Before you reach its gaping mouth, you have to make your way along the bottom of a steep-sided canyon draped with damp vegetation where the elegant ring-tailed mongoose glides, while a shaft of sunlight illuminates a giant day gecko, green with red specks, resting on a tree-stump. A few branches away, a Madagascar pygmy kingfisher in vermilion livery takes off suddenly.

Crocodile Cave is scarcely less impressive, when you know that these creatures do sometimes wander about the surrounding area, especially in the dry season when they come to look for coolness within the massif. Equipped with a torch and accompanied by a guide, you can visit some of the caverns populated with bats. But the jewel of Ankarana is undoubtedly Green Lake. It is about a four-hour walk to get there.

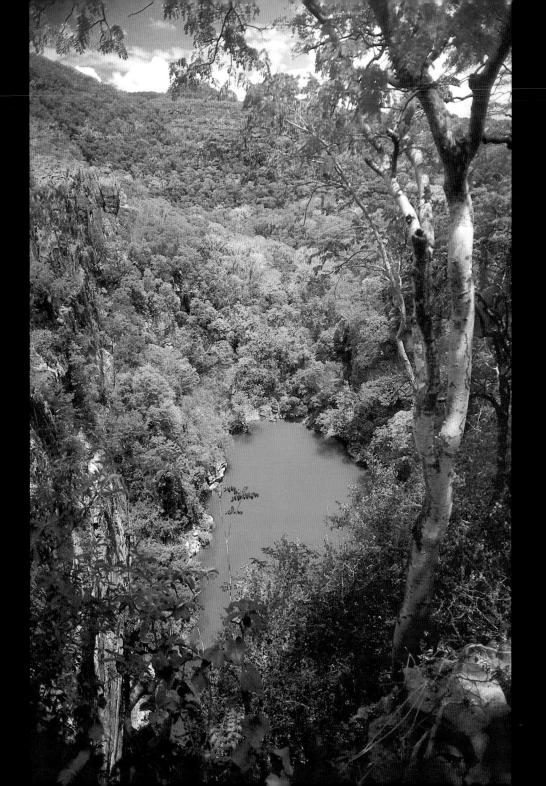

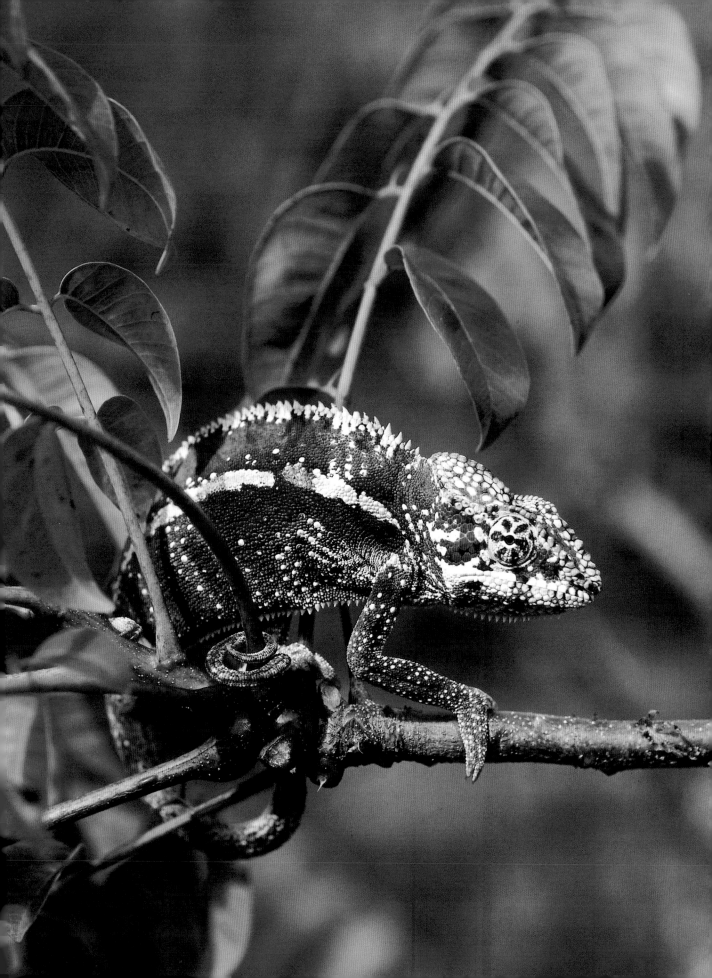

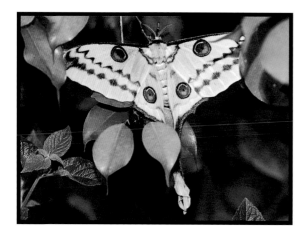

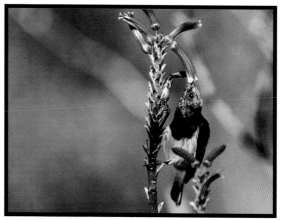

On the way, the vegetation may reveal the presence of a sleepy northern sportive lemur curled up inside a tree trunk, while a gaudy chameleon opts for a slow advance as it grasps the twig next to the plant on which it had for so long remained motionless. In the tops of the trees that cap the rock a small, but noisy, group of lesser vasa parrots peels berries. After crossing heavily eroded reliefs that make it difficult to move forward, at last round the bend in a path a sparkling emerald is revealed at the bottom of a geological setting formed by the tall tsingys punctuated by vegetation. The lake water, which owes its colour to the presence of microscopic algae, is populated with aggressive eels that do not hesitate to attack at the slightest disturbance of the water. The site is spectacular and is a good place to find the crowned lemur, whose feeding grounds are in the lower part of the canopy, doubtless to avoid competing with the Sanford's brown lemur with which it is sometimes confused. At dusk, you'll need to keep a sharp lookout amongst the leaves and twigs scattered on the ground for the greater hedgehog tenrec, a small prickly mammal with a long snout. The privileged environment of the Ankarana Special Reserve offers some of the wildest country left in Madagascar and for this reason it's undoubtedly worth the effort needed to explore it.

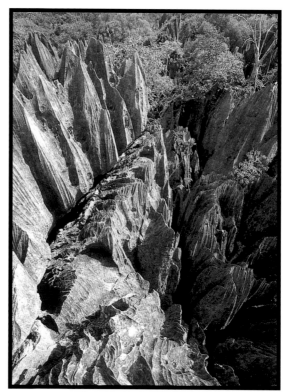

The panther chameleon has the most vivid colour combinations of all the chameleons. This one was taken using a medium long lens. A macro lens was used to take the nocturnal Madagascan moon moth or comet moth, Argema mittrei, which is one of the largest Lepidoptera in the world. With a wingspan reaching 30 centimetres, it is larger than the sunbird, whose long, slender beak coupled with a forked, tubular tongue allows it to drink nectar from the depths of the flowers. The photograph was taken using a telephoto, whereas a wide angle made it possible to obtain this high angle perspective looking down onto the tsingys.

Amber Mountain

Set up in 1958, the Amber Mountain National Park lies in the north of Madagascar, in Antsiranana province – or Diégo-Suarez to give it its other name. The name of the site is said to come from the colour of the resin exuded by trees, which the local inhabitants use in their traditional medicine. The Park is part of the Amber Mountain network of reserves comprising the Special Reserves of Ankarana, Analamera, and the Amber Forest. Its 18,200 hectares lie at an altitude between 850 and 1,475 metres, on a volcanic massif. Several crater lakes provide breaks in the overhead canopy and a multitude of rivers rise here, supplying water to nearby towns and villages. Located within the heart of a region subject to a dry tropical climate, the coolness and abundant rains that prevail on Amber Mountain nonetheless create favourable conditions for rainforests such as those in the east of the island. Broad footpaths lead to the Park's different centres of interest – starting with the Antomboka waterfall, a narrow ribbon of water shooting out from the vegetation to fall 80 metres.

On the way, you will spot many birds amongst the 76 species recorded. Although discreet, the gregarious white-throated oxylabe is not timid. It often joins a group of spectacled greenbuls, small birds with plumage that glints green and yellow. The area around the falls is also home to the crowned lemur. It lives in small groups that can sometimes be seen, especially in the rainy season, mingling with the Sanford's brown lemurs to look for food in the trees. On a more modest

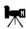

One of several leaf-tailed geckos, Uroplatus ebenaui is quite rare and little studied, being exclusively nocturnal and small in size. So coming across it in late afternoon in a clump of Amber Mountain vegetation is an unexpected stroke of luck. Taken by surprise, the reptile did however let itself be photographed using a macro lens and a tripod. A reflector made it possible to light it without needing to use flash. When alarmed, the gecko hangs from a hind leg to mimic a dead leaf.

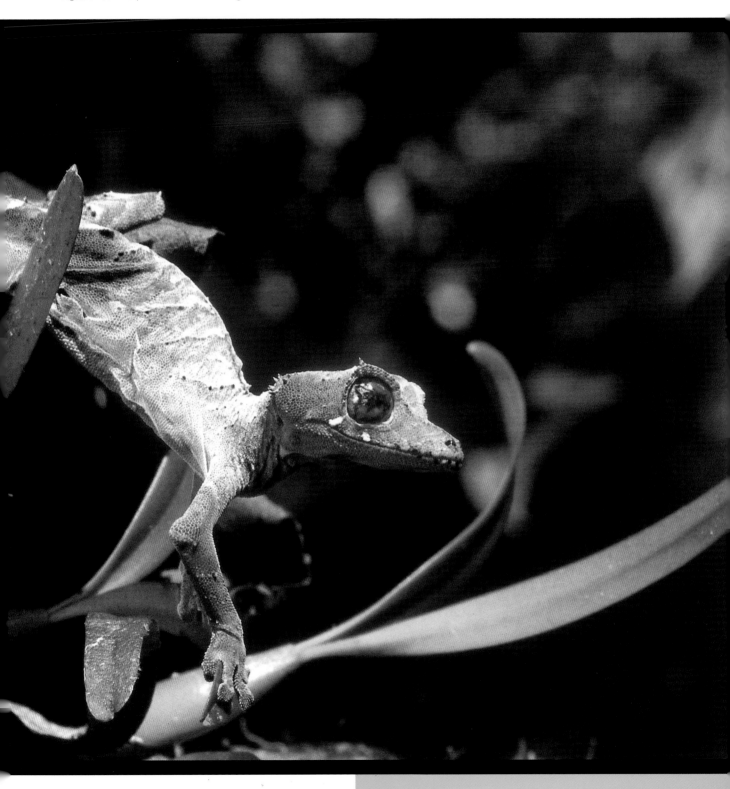

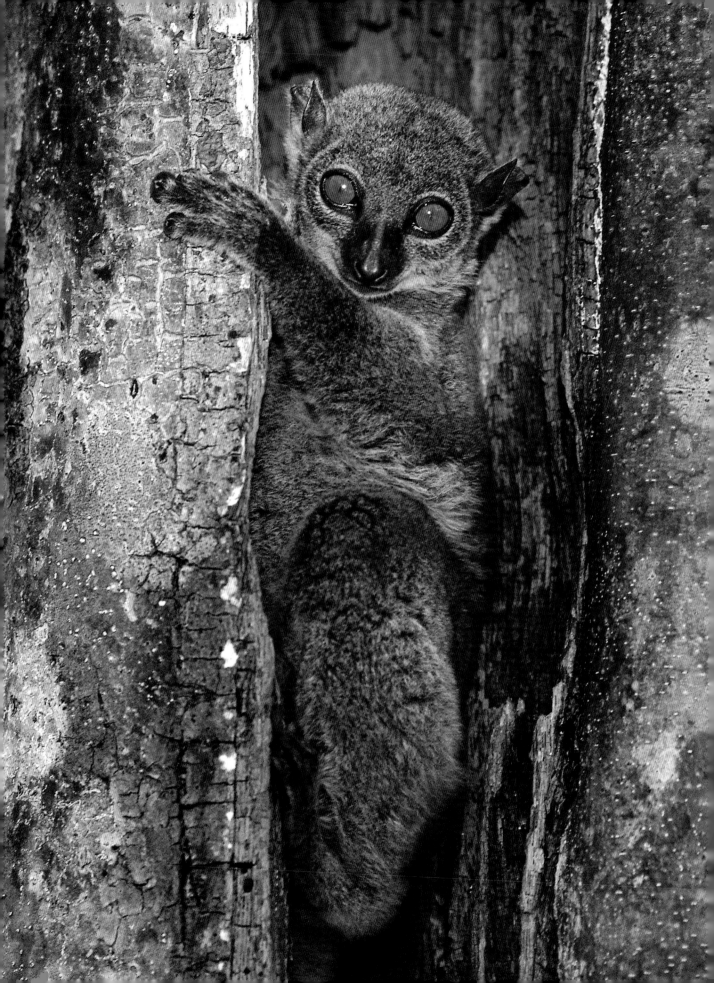

A northern sportive lemur was taken using a medium long lens and a tripod. To retain the atmosphere a reflector was used to bathe it in the warm evening light. Endemic to the extreme north of Madagascar, this nocturnal lemur is still one of the least-known species of the animal kingdom. Brookesia minima is one of 26 species of pygmy chameleons of this genus, all endemic to the island. A macro lens was needed to take the portrait of this tiny reptile, which is no more than two to three centimetres long. A wide angle and a slow shutter speed was used to take the Small Falls, the roar from which resounds amongst the trees.

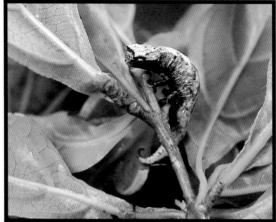

scale, the Antakarana waterfall is in an equally magical setting of cliffs dotted with tree ferns. A sub-species of forest rock thrush shares this habitat with other bird species like the furtive pitta-like groundroller, the dark newtonia – a Passeriforme with a stocky silhouette, and the Madagascar crested ibis, the largest forest ground bird, easily identifiable by its slender silhouette. At dusk, the area around the falls is alive with the jerky flights of bats, while the Madagascar pygmy kingfisher, in its coppery plumage with a hint of iridescent mauve, finds a shelter for the night. Before reaching the Sacred Waterfall, the path goes through the Les Roussettes Camp, a former forest study site dating from 1937, so-called from the presence there of large numbers of fruit bats, the majority of which have since deserted the spot. The campsite, now laid out for visitors, is the meeting place for crowned lemurs and Sanford's lemurs, as well as the Amber Mountain fork-marked lemur, a locally endemic variety of nocturnal lemur. The area around the Sacred Waterfall is also one of

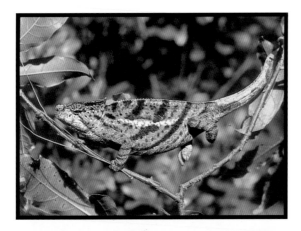

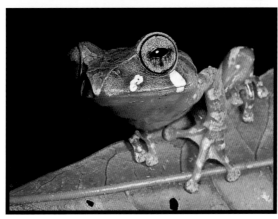

Very rarely seen, and only recently described, Calumma oshaughnessyi ambrensis is a locally endemic sub-species of the O'Shaughnessy's chameleon. It was taken here using a macro lens with fill-in flash, so as to give prominence to the ambient lighting. A frog of the Boophis family is a tree-dwelling amphibian, sometimes seen high in the branches, when it is active at night. The portrait of this specimen was achieved using flash and a macro lens. Photographed with a telephoto, a Sanford's lemur curls up in its fluffy tail to keep warm, waiting for the warming rays of the sun on a chill winter's morning. This male differs from a female in having an all grey head without any mane.

the best places for seeing it, once evening falls. Usually found towards the canopy, this lemur is not easy to spot however. Nightfall is also the time to look for the northern sportive lemur, a species that has been little studied, though we do know that it is preyed upon by the tree-dwelling boa, which lies in ambush by the hollow tree trunks where the lemur seeks refuge to sleep during the day.

The line of ridges running through the Park from north to south is underlined by a string of crater lakes that are yet more magnificent places to explore and include Green Cup Lake, Cursed Lake, Great Lake, Lake Texier and Lake Fantany. The extremely rare small-toothed mongoose (or falanouc) – a small mammal with twilight habits and a diet of insects – usually lives around these wetland habitats. The lakes attract birds like the furtive Madagascar flufftail and the Madagascar little grebe. Exploring the Park can also be an opportunity to encounter the most widespread of the carnivores on the island, the ring-tailed mongoose. On the other hand, the chances of coming across the fossa, although it is certainly there, are slim. This solitary, legendary animal is widespread in Madagascar, but only active at night, going to earth during the day. After sunset too, the aye-aye, a small nocturnal lemur scurries about and is capable of covering several kilometres in a single night to find food. Where a strangler fig grows alongside a path, a tracery of mosses, vines and epiphytic plants punctuated by creamy orchid flowers can be seen. Look closely at the leaf litter on the ground to spot the tiny Brookesia minima, one of the smallest chameleons. Some of the 36 species of butterflies found in the Park sometimes alight here too, with shimmering wings. This oasis amongst the clouds, in the hot, dry north of Madagascar, is a genuine paradise for naturalists of all persuasions.

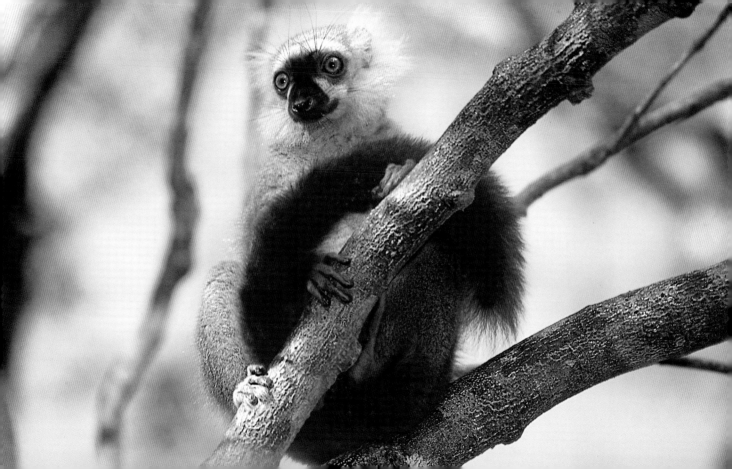

Protected areas cover half of the Masoala peninsula. The difficulty of getting there leads us to suspect that certain unexplored parts of this wild territory may be the refuge of animal and plant species yet to be discovered.

For scientists, Masoala is a veritable open-air laboratory, and has yet to reveal all its mysteries. To photograph the unique scenery of one of the last coastal wet forests on the island, a wide angle is recommended.

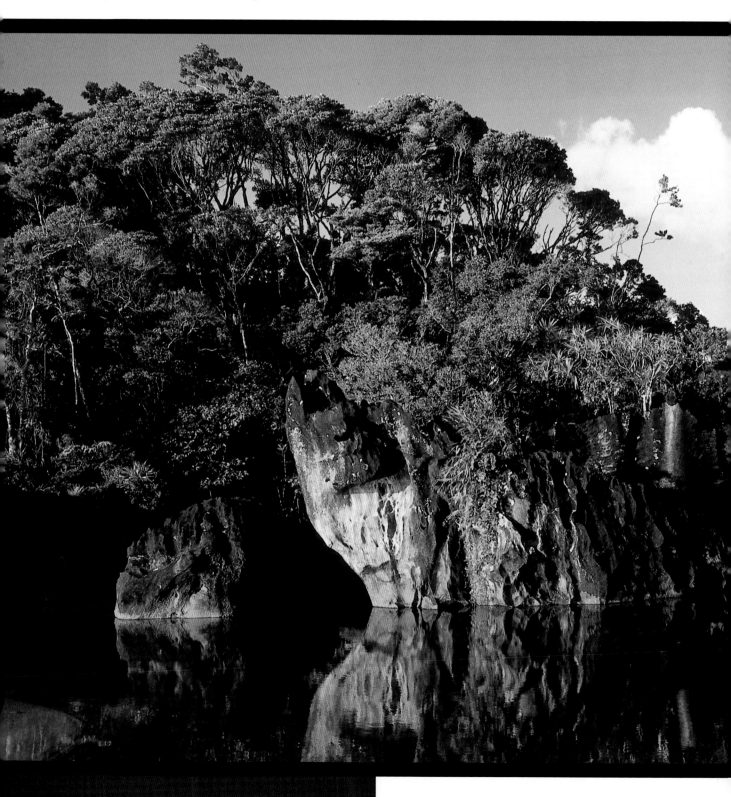

Masoala

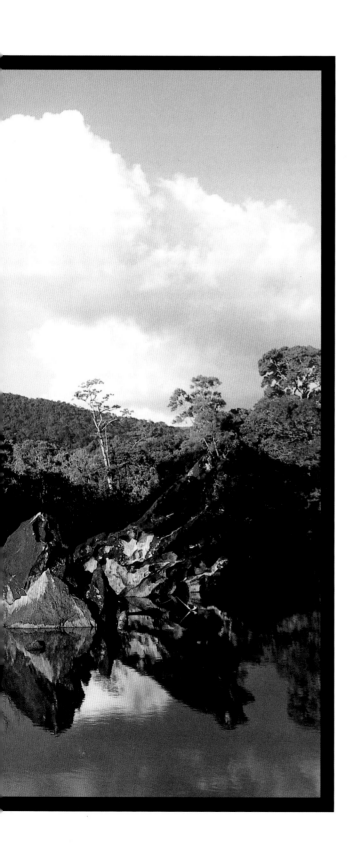

Neither road nor track serves the Masoala peninsula which straddles the provinces of Antsiranana (Diégo-Suarez) and Toamasina (Tamatave) in the northeast of Madagascar. It is difficult to get to, but the trails, each taking several days, nonetheless allow fit, highly motivated hikers to visit the region. The natural heritage here is such that the French colonists decided to protect part of it as long ago as 1927. Since 1997 the Reserve has become one immense complex of protected areas comprising the Masoala National Park; the three detached forest areas of Andranoanala, Andranomaintina, and Beankora; the three Marine Parks of Tanjona, Tampolo, and Masoala; and the Nosy Mangabe Special Reserve. In all the Reserve covers a total of 230,000 hectares, making it the island's largest conservation area. The peninsula is home to one of the last primary forests on the planet. Masoala is the wettest region in the country, with average annual rainfall of over 4,000 mm.

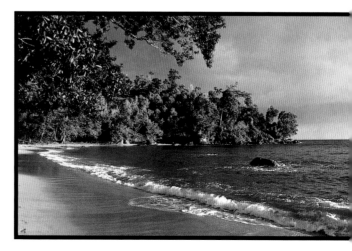

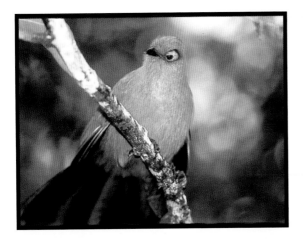

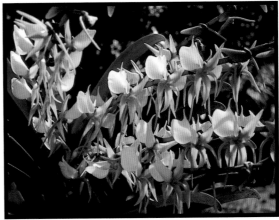

(tripod/camera icons)

In the heart of the primary forest, the blue coua was taken using a medium-long lens, thus confirming that it is not very timid. A wide angle was used to take both the sprays of spotless Angraecum superbum orchids and the strange mushrooms that enliven Masoala's vegetation. A tomato frog, endemic to Antongil Bay, exhibits a warning colouration, indicating that it is poisonous. It also defends itself by another subterfuge, exuding a whitish mucous that gums up the mouths of any predator which attempts to attack it. Even smaller than Brookesia minima, this pygmy chameleon, Brookesia peyrierasi, may be the smallest chameleon in the world, so a macro lens is essential.

Over 90 percent is covered by a wet forest whose height in places exceeds 30 metres. In the west, the rugged relief rises sharply from the coast to reach 1,224 metres, before sloping more gently down towards the coastal plains in the east and south. Apart from a few mangrove strips, Masoala is characterised by the presence of coastal lowland forest that festoons the beaches of coral sand. Masoala's tangle of tropical tree varieties is the unique kingdom of the rarely seen red ruffed lemur. The distribution area of its cousin, the white fronted brown lemur, is more extensive, but you are most likely to see it a little way from here, on the small island of Nosy Mangabe in Antongil Bay, where like the harmless aye-aye it haunts the island nights. The bay is renowned for the observation of hump-backed whales that come here to calve between July and September. On the shore of the bay, where stilted mangroves protect the coastline from erosion, Ambanizana Forest, although hard to get into, is a good place to find the weasel sportive lemur that calls out in the canopy when evening falls. Also nocturnal and sadly not very visible, the eastern fork-marked lemur is a rarity.

At home in the massifs of primary forest, the helmet vanga is a huge bird whose enormous hooked blue beak avoids confusion with any other species. The murky undergrowth is home to the scaly ground-roller, which

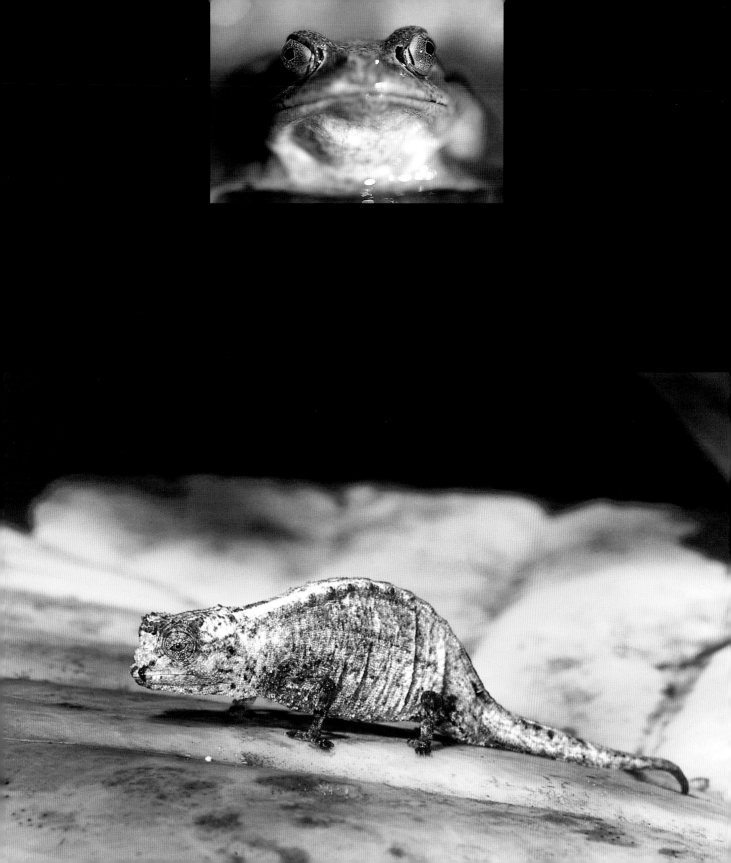

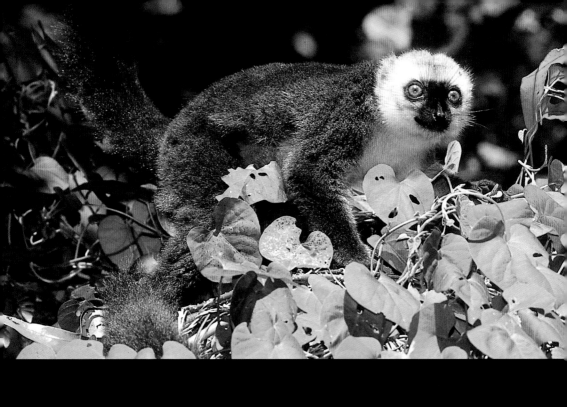
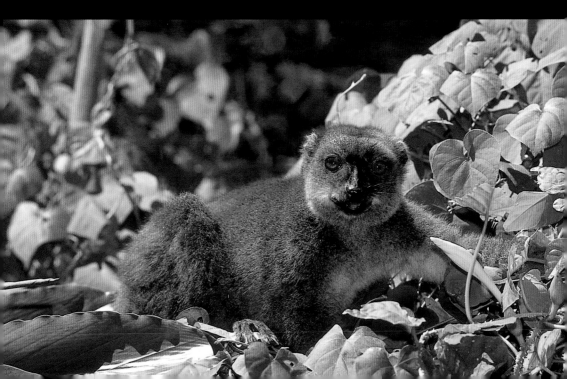

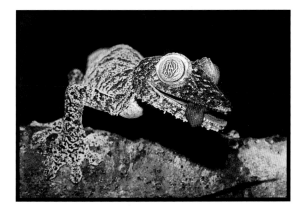

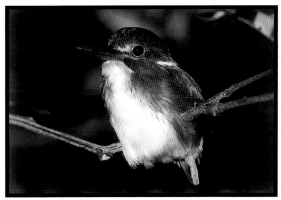

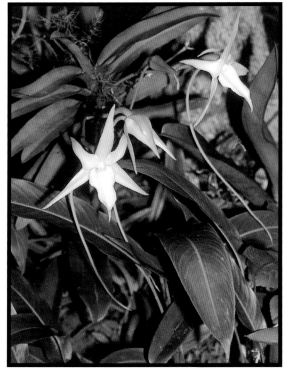

The photographer surprised a pair of white-fronted brown lemurs, stuffing themselves on leaves. A medium long lens has made it possible to capture their expressions. These pictures are also of interest as they illustrate the dichromatism of the male (top) and female (bottom). The mischievous leaf-tailed gecko is a nocturnal reptile, which can be up to 30 centimetres long and this portrait was taken using a macro lens. The Madagascar pygmy kingfisher, perching on a slender branch, was taken using a medium long lens. Using a wide angle, the comet orchid appears to flower at the end of tentacular stems, but they are, in fact, spurs on the flowers.

likes the heavy carpet of dead leaves where it looks for invertebrates that form the basis of its diet. Perched on a branch less than one metre off the ground, the red-breasted coua, recognisable by its red cravat, is always ready to make a quick getaway; at the slightest alarm, it will disappear off into the greenery, running with its body horizontal. Less fearful, the russet mouse lemur is undoubtedly easier to spot, as its populations are reputed to be numerous and its density is high along all the western side of Madagascar. Amidst the bamboo thickets that provide its food nests the grey gentle lemur, and in the oppressive humidity, large, iridescent butterflies sometimes escort the walker. On the ground, the mossy branches hide the cryptic chameleon, while a mossy leaf-tailed gecko stays motionless and invisible on the bark of a giant branch stretching up towards the sky. The difficult paths winding through the massif resound to the roar of the mountain streams and rivers flowing through the vegetation, which create favourable conditions for a multitude of frogs, of which the tomato frog in its scarlet livery is one of the strangest examples.

The forest and its seasonal marshes are also a refuge for the small-toothed mongoose, a small civet locally called falanouc, characterised by its enormous, very bushy, cylindrical tail. Largely unexplored, and still reserved for the experienced traveller although gradually opening itself up to tourism, Masoala is far from having revealed all its secrets.

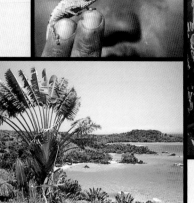

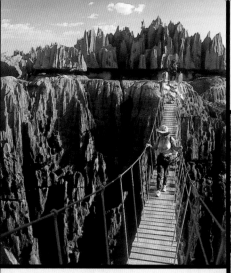

Practical information

FORMALITIES

A visa is required together with a passport valid for at least six months after your return. You also need to have a return ticket or a Travel Agency's return confirmation.

LANGUAGE

Malagasy is the official language. It is a dialect of austronesian origin mixed with Arab, English, and French influences. French, however, remains the language of politics and business in spite of the 'localisation' or 'Malgachisation' policy adopted in the 1970s after independence and 'ecolonising' the country.

CURRENCY

MGA, or Malagasy Ariary, also referred to as Malagasy Franc. Outside major hotels and airline companies, credit cards are rarely accepted. Traveller cheques are minutely evaluated and exchanged in banks.

ELECTRICTY

220 volts.

TIME ZONE

GMT + 3 hours.

CLIMATE

With a tropical climate, milder in high altitudes, warm days sometimes end with thunderstorms, especially during summer which is from December to February. Cold winter nights from June to August could end with a light, early morning frost. Facing the Indian Ocean trade winds the eastern side of the Island, while usually sunny, gets more rainfall. It can rain throughout the year, but the peak period is in the summer during the hurricane season. Temperature varies only moderately,

staying stable at about 20 degrees centigrade. While the north of the island is also under the influence of a humid tropical climate, rainfall occurs mainly between December and June and is lighter than in the east; the temperature is regularly higher than 30 degrees centigrade. In western regions the temperature is higher on average, with less variation from one season to another. Hindered by the mountain barrier, rain is lighter than in the east.

The south of the island is where the sunshine is more abundant, and the weather warmest, but nights are cool in winter. It is however the driest region, with sometimes the fewest hours of rain during the year and occurring in December and January.

LUGGAGE

Clothing: light for daytime: shirts, T-shirts, Bermuda shorts, shorts; warmer for morning and evening: trousers, pullover, fleece, lightweight jacket. Footwear: one pair of stout, high-topped walking boots and a lighter pair. Other: hat, sunglasses, sunscreen, anti-mosquito lotion, torch, spare batteries, personal pharmacy, toilet paper, water purification tablets, light bags (for independent travellers), vaccination cards, passport with valid visa, plane ticket, credit card and local currency in cash.

PHOTOGRAPHIC EQUIPMENT

Camera bodies, lenses, flash, tripod, filters, memory cards, films, spare batteries, rechargeable batteries and charger (digital equipment is very power-thirsty), cleaning kit (blower, brush, soft cloth), bag to protect against dust. Be sure to carry film in your carry-on baggage because the powerful X-rays used on checked baggage will damage films. Photographers using digital equipment should take a portable hard drive to offload their image files from the memory cards. Taking two camera bodies will reduce the risk of getting dust on the sensor caused by repeatedly changing lenses.

ACCOMMODATION

Tourism infrastructures are still not well developed in Madagascar. There are some prestigious hotel chains, particularly in the cities and seaside resorts, but in most cases the hotels are unevenly distributed across the island and are more modest. In the centre of the country, hotels dating from the colonial period offer a degree of comfort and hygiene that varies between establishments. Most villages do however have one or more unclassified hotels that can offer pleasant surprises. There are also lodges, some of them located inside the parks and reserves, which allow you to set off early in the morning to see the

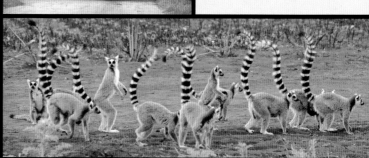

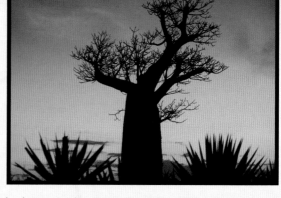

animals. Camping is not regulated and there are no proper camp-sites, but it is possible and, depending on the location, may be the only solution, only you need to take your own equipment. You are strongly recommended to hire a guide who will show you the authorised places inside the National Parks or close to the villages, and how to avoid infringing the 'fady' (taboos). It is also necessary to watch out for biting insects and check boots for scorpions. Madagascar really is an island where wild nature reigns supreme.

GETTING AROUND

It would be unrealistic to expect to visit the whole of Madagascar in a fortnight. The island is huge and getting around is not easy. Internal airlines do land at sixty or so places, and certain locations can only be reached by plane. Quite apart from the high fares, flights are rarely on time, because of weather, strikes or breakdowns. The rail network is not well developed; only four lines serve the entire country, and operate at an extraordinarily slow speed. This leaves the roads, where you have to contend with the notorious bush taxis – overloaded vehicles that guarantee visitors a totally new and unforgettable experience. It is also possible to hire a 4x4 vehicle, with driver. This is a good idea as the roads often deteriorate and become

dangerous. In a country where place-names vary depending on which map you use, where signposts are rare, and where vehicle breakdowns are common, the driver is a useful ally, not just to avoid getting lost, but also to initiate the traveller into local habits and customs. Within the parks and reserves, hiking is generally the best way of discovering the richness of the sites.

PARKS AND RESERVES

Madagascar is a mysterious land that still has a scent of prehistory about it. Only four centuries ago, you could have found the legendary elephant bird, Aepyornis maximus.. Larger than an ostrich, this bird was exterminated by human appetite for its meat and eggs. Madagascar was also once home to the giant lemurs; but they too have disappeared. Nowadays, the creatures that inhabit the island are smaller but no less unique, so protecting them is vital. In an island with a record number of endemic species, the preservation of the environment is critical for their survival. The Madagascan government, supported by the international community, seems to have recognised this, since it is seeking to triple the current protected areas. In 1990 the ANGAP (National Association for Managing Protected Areas) was created, and is responsible for implementing a programme for conservation of Madagascan

biodiversity and managing it sustainably. Parts of the territory, on land or in the sea, with a particular biological, archaeological or cultural heritage, enjoy varying degrees of protection. The number of National Parks has increased from just two in 1991 to 18 now, and is constantly changing as reserves are upgraded. These are accessible to the public for an entrance fee. In addition, there are 11 Integral Nature Reserves – in principle reserved for scientists alone, and 25 Special Reserves sheltering endangered animals or plants, but where the local populations retain a right of usage. There are also one Biosphere Reserve, 167 listed forests, 93 forest reserves, 23 forest stations and 128 reforestation zones. In total, these areas cover 6.8 million hectares, on some 12 percent of the island. This is not excessive, when you realise the damage caused to the environment by human activities such as deforestation, agriculture and poaching. Yet it is hard to blame people that live in such great poverty, with no other sources of income, for these actions.

Photographing nature

A favourite naturalist destination, Madagascar offers a safari quite unlike nearby Africa, or indeed, India. Instead of large herbivores and carnivores, the main mammalian attractions are the enchanting lemurs and small carnivores like the civet or the legendary fossa. A colourful array of frogs, impressive but harmless reptiles, insects and birds plus geological, maritime and tropical forest habitats abound.

You cannot improvise on a visit to Madagascar. The island is vast and the haphazard quality of the road network makes it impossible to cover long distances quickly. It is therefore important to be well informed before you set off, so you can select the best itinerary for the time available. Apart from the island's geography being very diverse, so are the climatic variations; the rains, in particular, are unevenly distributed depending on the region. Picking the wrong season for your journey can be a disaster. Madagascar's flora and fauna are for the most part endemic, with most of the species not found anywhere else on the planet. Thus the indri, the largest of all the lemurs, can only be seen in the protected areas in the north-eastern quarter of the island, more specifically in Andasibe-Mantadia, and nowhere

else in Madagascar. It is equally important to find out about the state of the terrain, for in Madagascar, the parks and reserves are explored on foot. Fortunately, the island does not have any dangerous large animals. Although you can go around in shorts and a T-shirt in Isalo, in the wet forest areas, such as Ranomafana, because of the leeches and mosquitoes it is safer to travel in trousers and long-sleeved shirts. A pair of sturdy walking shoes is also indispensable. The circuits generally do not present too much difficulty, but sometimes the paths are steep and so they demand a good level of physical fitness; others, as in Ankarana, are specifically intended for more experienced sportsmen and women.

Special permits are required to visit certain reserves, and it is most often recommended, and sometimes even obligatory, to use the services of a local guide. The best of these are very knowledgeable about the terrain and the habits of the animals, and will be able to take visitors to the points of interest on each site without detours. Footpaths offer circuits of varying durations and make it possible to penetrate quite a long way into the hearts of the parks and reserves. In the confined spaces of the wet forests, just as in the region of the sharp tsingys, you will have to carry your own equipment, so a photographic backpack is strongly recommended. The density of vegetation in tropical forest habitats restricts the sunlight reaching the ground. Shooting with wide aperture lenses fitted with stabilisers is advisable, not forgetting to increase the ISO setting on your digital camera, to be able to use higher shutter speeds. Film users will find faster films useful for working inside the forests. A tripod is not only useful for providing stability when shooting in low-light conditions, but essential when using telephoto lenses. Long, heavy lenses are invaluable for photographing birds but may not always be necessary for confident mammals that will

tolerate a closer approach. Flash is an indispensable accessory for photographing species that live deep in the vegetation, especially in certain parks and reserves where excursions may be organised after nightfall to see the nocturnal fauna such as lemurs and chameleons.

For photographing landscapes, whether they are rocky massifs or rainforests, a wide angle lens is essential for embracing the scene and for getting memorable pictures that portray the habitat to best advantage. The ruin-like reliefs in Isalo suggest obvious compositions, whereas the jumble of vegetation in the forests requires special attention. You need to let your gaze linger on details such as backlit foliage, the graphic quality of tangled branches, or a well-structured tunnel of greenery. A medium focal length zoom of say 70-200mm – with a large aperture – is no less useful and offers a whole range of framings. Madagascan wildlife includes numerous small creatures, such as geckos, chameleons, moths and butterflies, as well as some unique plants, so a 60 or 105mm macro lens is an advantage for documenting the smaller inhabitants.

The state of the terrain – access on foot, steep reliefs and density of plant life – make wildlife photography quite difficult in Madagascar. Fortunately, nature photographers are usually curious, patient, and determined – all indispensable qualities for capturing a lemur taking off, a trotting mongoose, or watching and waiting for the perfect light to convey the inextricable labyrinth of the tsingys. The interest of Madagascar comes as much from its diversity – and especially from the large number of endemic species – as from its sheer wild beauty. As natural habitats continue to shrink, wildlife photographers can play an important part in highlighting those riches that need to be conserved.